manet

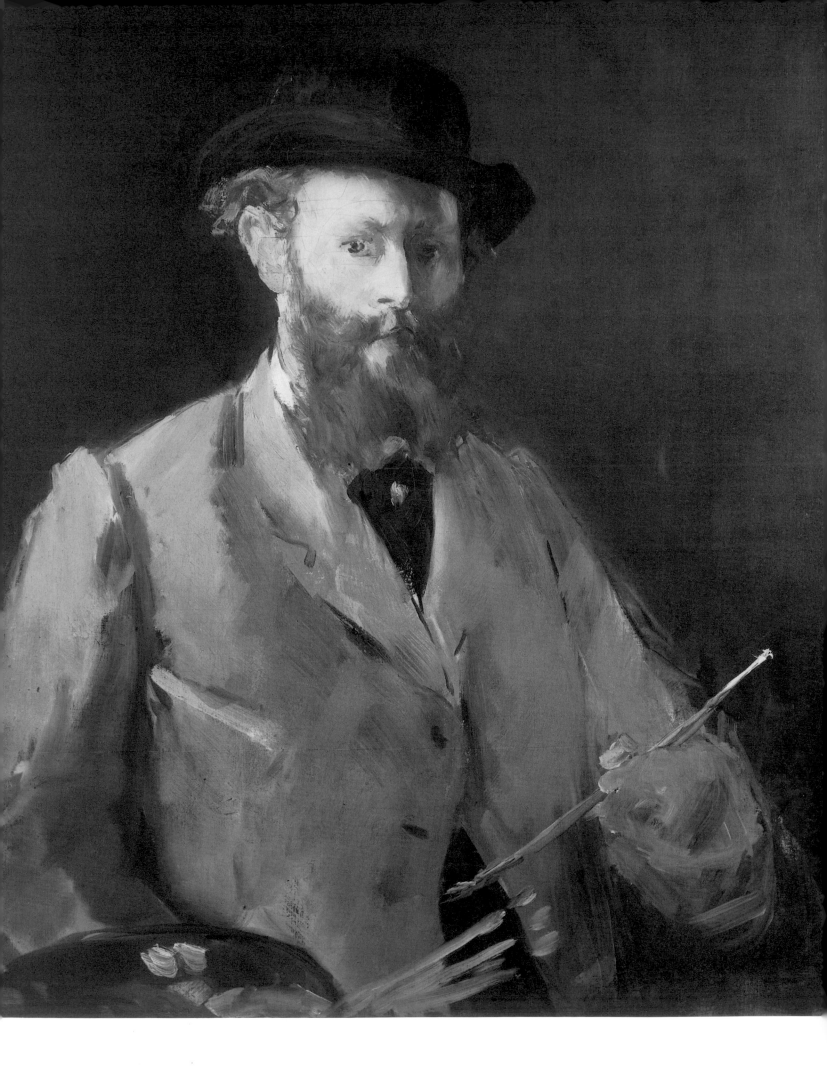

edouard manet

pierre courthion

HARRY N. ABRAMS, INC., PUBLISHERS

Self-Portrait with Palette 1879
Oil on canvas, 32 5/8 x 26 3/8 in.
Collection Mr. and Mrs. John L. Loeb

Contents

Plates

edouard
manet

The name of Manet evokes what seems self-evident in the light of day, and at the same time the hidden difficulty, the engaging smile of life itself, and pure native talent. Our eyes are so accustomed to his luminous canvases that we can scarcely believe the intrigues that tormented him each year at the time of the Salon. The public no longer even contests the painter's right to a free choice of subject matter. Today **Olympia** is in the Louvre.

On the surface there was nothing particularly unusual about Manet, either in character or appearance. He was agile and had slightly disheveled blond hair, a direct look, and a straight nose. He was sensitive to the pulse of the crowd but was never tormented by internal conflicts or heartbreak, nor did he pour out his feelings in a diary. While he had the quick reactions of an impassioned temperament, he took care at the same time to dress well. In short, he seemed very much the Paris gentleman. And yet, in his letters to his family (including some that he sent his wife in 1870 by balloon from besieged Paris) I am struck by certain themes which seem to me important in understanding him: an attraction for everything visual, a love of city life, and an understanding of women.

In Manet we have just the opposite of a Rembrandt or a Delacroix. His work was already, as that of Matisse was to be later, what is now called *peinture-peinture*, or pure painting. There is no psychology and nothing to allow us to glimpse the secrets of mind or heart. Manet, if one likes, is a painter of the epidermis, but the exterior elements of his representation have no connection with the surface appearance of nature. The value of his art lies in the brush stroke, the color, and the creative light with which it sparkles. The so-called epidermis has acquired pictorial value.

Manet is one of the few portraitists of all types of femininity who have succeeded in imparting their own hungry love of women to the colored forms. When we look at a painting by this Frenchman, we feel a breath of Paris air: in the swish of a skirt, a perfume of tea-roses; in a stroke of oil or pastel, a feminine figure silhouetted for a brief second before it makes way for another. Jacques de Bietz once spoke of the "transparent, mother-of-pearl texture of these feminine skins," over which the brush had "passed gently, as lightly and penetratingly as a caress."

Today when I think of Manet, who painted luminous flesh and shining eyes in the world's loveliest light, I seem to see a veritable procession of delectable women—from Victorine Meurend, the wholesome wench with the almost Flemish skin in *Luncheon on the Grass* and *Olympia*, to the popular actresses, visiting Americans, and numerous society women whose silhouettes he outlined in pencil during his last years. I am attracted by the almost languishing charm of Lola de Valence, by the blue-tinted whiteness of Mme Manet seated at the piano, by the Spanish stiffness of Berthe Morisot in **The Balcony**, and by her feline suppleness in **Repose**. I can still see the little girl with the blue bow in **Gare Saint-Lazare** and Nina de Villard, the coquettish lady with the fans, "tiny, plump, animated, and some-what hysterical," stretched out on a divan in her wide, pleated skirt. I recall the healthy vulgarity of **Nana**, painted in 1877, two years before Zola's novel appeared, and the dazzling coloring of the **Blonde with Bare Breasts**, whose ripening beauty fascinated young Lathuille. My eyes rest on Mme Le Josne's veil in **Music in the Tuileries**, on the tragic profile of Mlle Martin, on the fan carried by the Countess Albazzi, the Polish woman brought to the atelier in the rue d'Amsterdam by George Moore, who described her mouth as "resembling a red fruit." (She is said to have been driven there in a carriage drawn by horses from the steppes.) The rather bovine charm of the singer, Mme Valtesse de la Bigne, one of the lionesses of the Second Empire, leaves me more or less indifferent; I prefer the saucy nose of the Viennese Irma Brunner, the friend of Méry Laurent. A famous beauty, Méry finally replaced Victorine Meurend as Manet's regular model. She was the mistress of Dr. Evans, the dentist of kings and emperors; we see her in a black hat or fullface and wide-eyed, and, as Mallarmé says, "inviting the laughter that besprinkles her." Standing or seated, leaning on the arms of chairs, wearing straw hats or little velvet toques, a parade of women—creole, Russian, English, and even at times a real Parisian—passes before our eyes. In all these pictures the women are not mere images. Manet has given them a personality and a background of their own. And above all, he relishes them as he would ripe fruit.

These miracles of urban charm are the creation of a boulevardier who would have liked to paint like Cabanel and become a successful, fashionable painter. But in spite of this, he also felt the need of defying a misunderstood tradition, perhaps because he could not paint as people had painted before him, in full, rounded forms with chiaroscuro shadings. For this reason, according to Hippolyte Babou, he was accused of "seeing the outside world in spots and patches, as though he were looking at it with dazzled eyes." One day, in reply to a question on the subject of Manet, Courbet declared that he painted people as flat as the figures on playing cards. "Naturally," Manet retorted to the friend who had repeated this quip to him, "Courbet's own ideal is a billiard ball!"

The fact is, that while Courbet brought to his work something of the ruggedness of his native Jura and the damp moss of forest undergrowth, Manet gave us the color of Paris itself, a bit of pink sunlight playing over stone that is still covered with mist. "In the evening," a contemporary wrote, "his greatest pleasure was to go to some Batignolles café,

1 Fantin-Latour: **Portrait of Manet** 1867
Oil on canvas, 46 x 35 1/2 in.
The Art Institute of Chicago

2 Leon Koëlla-Leenhoff, from a photograph

1

2

where, with his beret over one ear and his pipe in his mouth, he would plead the cause of modern painting. On these occasions he let fly through his curled-up mustaches the maddest of paradoxes, the most bantering of quips and sallies." Here too, this son of well-to-do parents, gone astray among the *avant-gardistes*, all of whom were poor, often lent comfortable sums to his friends. Monet, Villiers de l'Isle Adam, Zola, and others less well-known all had recourse to his generosity.

Edouard Manet was born on January 23, 1832, in the heart of Paris, at 5, rue des Petits-Augustins (today rue Bonaparte), just opposite the École des Beaux-Arts. He was given his first schooling at the rather bleak Collège Rollin, after which he was sent aboard a training ship to learn to be a pilot. It was hoped that he would gain enough experience to pass the entrance examinations to the École Navale that he had failed earlier. When his ship made its first call in Rio, he

wrote home to his parents describing the blue skins of the negresses "naked to the waist," who "twist turbans about their heads and wear skirts trimmed with enormous ruffles."

At the age of eighteen, Manet finally obtained permission from his father to devote himself entirely to painting. He started working at the École des Beaux-Arts in the atelier of Thomas Couture, who examined his efforts with more or less absent-minded attention. Mallet's biographers have tended to pass rather rapidly over Couture, who had been a pupil of Gros and was a great admirer of Velázquez, and who understood the principles of color and its harmonies. In order to estimate how much Manet owed him, we have only to look at Couture's **Little Giles** in the Philadelphia Museum of Art. Except for the chiaroscuro, this picture could have been painted by Manet himself. But even as a student Manet knew what he wanted. On Mondays, when the models took their pose on the table, he would call out to them, "Can't you be

3 Fantin-Latour: **Studio in the Batignolles Quarter** 1870
 From left to right: Scholderer, Manet, Renoir, Astruc (seated), Zola,
 Maitre, Bazille, Monet
 Oil on canvas, 68 1/2 x 82 in.
 The Louvre, Paris

4 **Mme Manet at the Piano** c. 1867
 Oil on canvas, 15 x 18 in.
 Museum of Impressionism, The Louvre, Paris

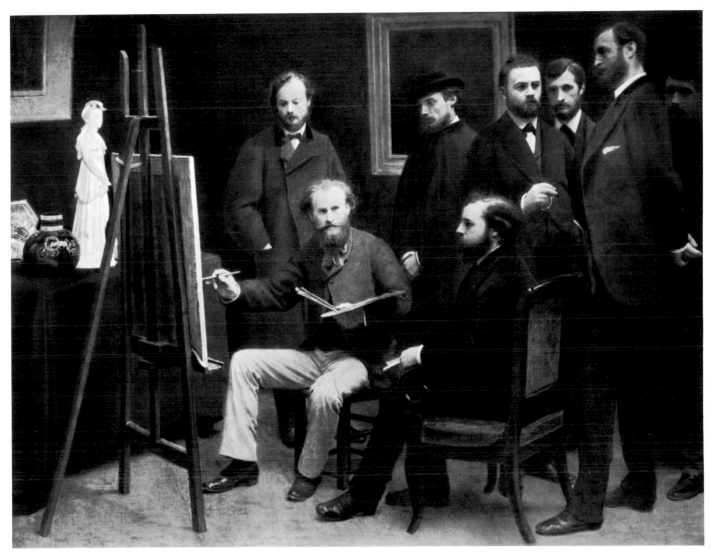

3

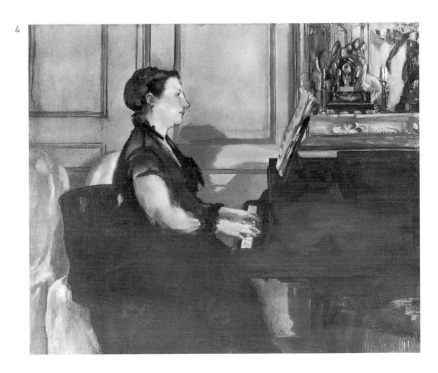

4

5 **The Street Singer** 1862
Oil on canvas, 69 x 42¾ in.
Anonymous Loan to the Museum of Fine Arts, Boston

6 **Portrait of Mme Brunet (Woman with Glove)** 1860
Oil on canvas, 52 x 39¼ in.
Collection Mr. and Mrs. Charles S. Payson, New York

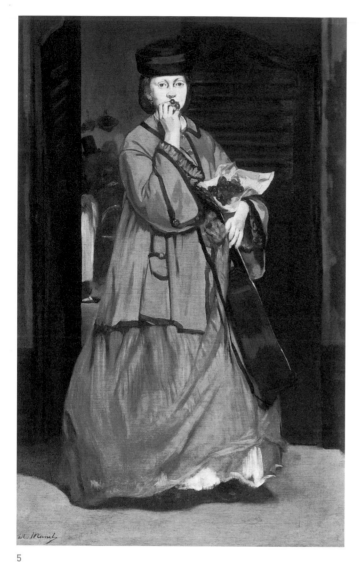

5

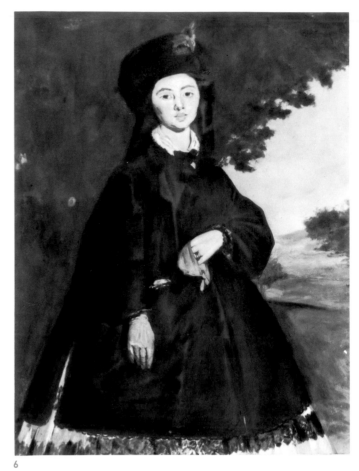

6

natural? Do you stand like that when you go to buy a bunch of radishes at the greengrocer's?"

After short periods in Italy and Germany and some time devoted to copying the old masters, he painted his first studies in his studio in the rue Lavoisier, under the influence of the Velázquezes and Goyas in the Louvre. By the time he made his debut at the Salon with the **Guitarist** in 1861, a small group had already formed about him. "This young man should not paint like Velázquez," Courbet exclaimed in the Taverne Andler, where the younger painter was beginning to be as welcome as he had been on the boulevard des Batignolles. The traditionalists rubbed their hands with delight at the prospect of this division among the modernists.

According to Antonin Proust, Manet at that time "invariably wore either a tight-waisted jacket or a morning coat, with light-colored trousers and on his head a hat with a very high crown and a broad, flat brim.... He was always well

shod, and, armed with a light cane, went about whistling or punctuating his sentences with slight nods." He liked to sit on the terrace of one of the boulevard cafés, at Tortoni's or at the Cafe Riche, watching the women stroll by.

The year 1863 was an important one for Manet. In the early months he had an exhibition in Louis Martinet's gallery, where he showed for the first time **Ballet Espagnol**, **Lola de Valence**, and **Music in the Tuileries**; then, in May, he took part in the so-called Salon des Refusés. Finally, in October of the same year, just twelve months after his father's death, he left for the Dutch town of Zaltbommel, in northern Brabant, to legalize by marriage his long-hidden liaison with Suzanne Leenhoff. He had known her since the age of twenty, when she gave him piano lessons. According to Tabarant, in 1852 she had borne him a son, Léon Koëlla-Leenhoff.

He had not yet moved to the apartment at 34, boulevard des Batignolles (at that time, his studio was still in the rue

7 **The Old Musician** 1862
Oil on canvas, 73 3/4 x 98 in.
National Gallery of Art, Washington, D.C.
(Chester Dale Collection)

8 Mme Brunet

9 Couture: **Little Giles**
Oil on canvas, 25 3/4 x 21 1/2 in.
Philadelphia Museum of Art
(William L. Elkins Collection)

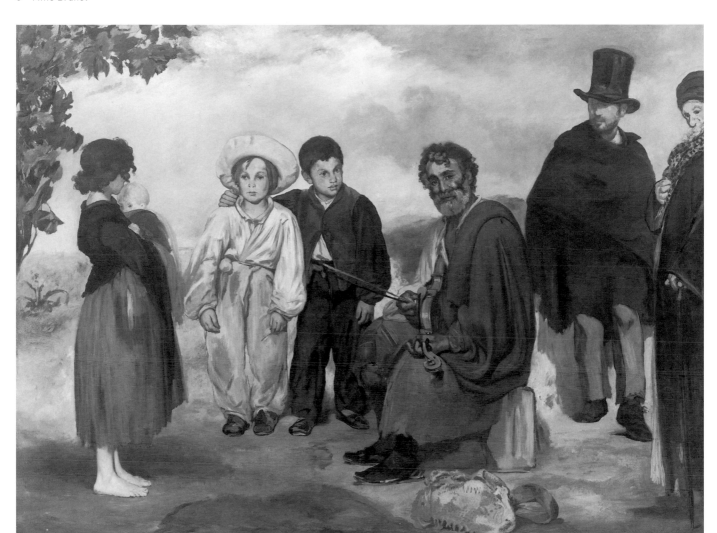

7

8

9

10 Marcantonio Raimondi: **The Judgment of Paris** c. 1525-30
Engraving after a lost cartoon by Raphael.
Manet used the group of figures in the lower right-hand corner for
Luncheon on the Grass. (See below and plate, page 61)

11 Giorgione: **Pastoral Concert** c. 1510
The Louvre, Paris

12 Study for **"Luncheon on the Grass"** 1862
Watercolor and ink, 13 3/8 x 15 7/8 in.
Collection Bruno Cassirer, Oxford

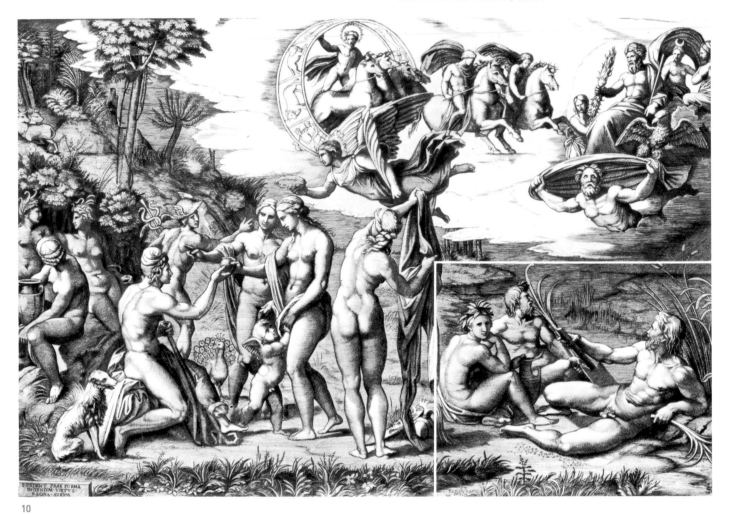

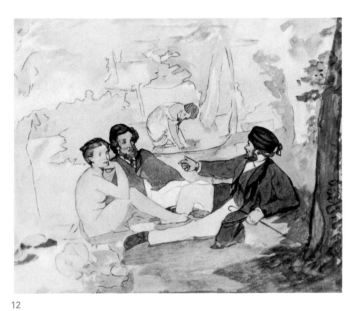

10

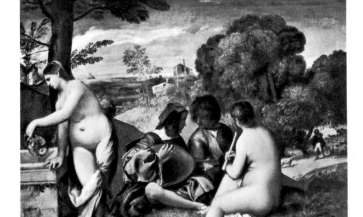

11

12

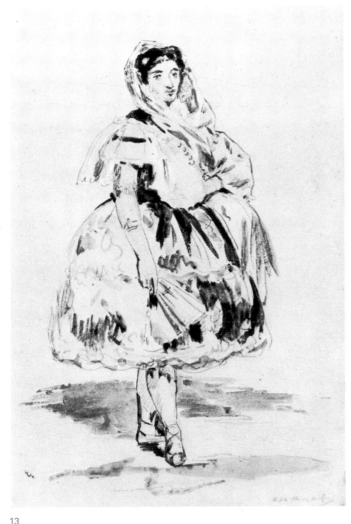

13 **Lola de Valence** 1862
Watercolor, ink, and wash, 10 x 6 7/8 in
The Louvre, Paris (See plate, page 57)

13

14 Goya: **Majas on a Balcony** c. 1810–15
The Metropolitan Museum of Art, New York
(Compare with plate, page 83)

14

Guyot), when **Luncheon on the Grass** was refused by the jury of the Salon. In 1865 **Olympia** was accepted and caused a tremendous scandal. "Manet has made a dent in public opinion," Champfleury wrote Baudelaire. But his painted heroine, whom a certain Amadée Canteloube in *Le Grand Journal* called "a female gorilla, a rubber grotesque," was far from well-received. Paul St. Victor, writing in *La Presse* on May 28, was fuming: "People crowd about M. Manet's rancid Olympia as though they were at the morgue. When art descends as low as this, it does not even deserve a note of censure." Manet was also accused of being a "brutal type of man who paints women green with a scrubbing brush." Discouraged by this animosity, he left for Spain to seek a change of atmosphere. When he returned, he had acquired a new supporter, Theodore Duret, whom he had met at a hotel in Puerta del Sol.

Now there were meetings at the Café Guerbois or in his own studio. Having been ruled out of the 1866 Salon, he followed the example set by Courbet and in 1887 had a wooden shed erected on the Place de l'Alma to house a one-man exhibition. On this occasion, he published a tiny catalogue (well printed, in two colors), and gave in the preface the reasons for his decision: "This artist was advised to wait. Wait for what? Until there are no more juries? He preferred to settle the question with the public. In fact, what he would like to do is to become reconciled with the public, whom others have made into his supposed enemy. For time acts upon pictures with an irresistible buffer that smoothes out all their original uncouthness." And he added, "M. Manet has always recognized talent wherever it happened to be and does not claim either to overthrow traditional painting or to create a new style. He has simply tried to be himself and not someone else."

In 1867 Monet's contribution to the Salon was the dashing **Portrait of Camille**, in which Manet's influence was generally recognized. The humorist, Andre Gill, writing in *La Lune*, wrote the following students' joke about Monet's **Camille**, "Monet or Manet? Monet. But we owe this Monet to Manet. Bravo, Monet! Thank you, Manet!" Manet himself was not

15 **Bullfight** 1864
Oil on canvas, 18 7/8 x 42 3/4 in.
The Frick Collection, New York

16 **The Dead Toreador** 1864
Oil on canvas, 29 3/4 x 60 1/2 in.
National Gallery of Art, Washington, D.C. (Widener Collection)

17 Caricature of **Incident in the Bull Ring** by Cham in Charivari,
May 22, 1864. This cartoon is all that remains to show us what
Manet's painting **Incident in the Bull Ring** may have looked like.
The two remaining portions of the painting are reproduced at left,
but not to the same scale.

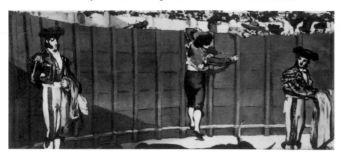

15

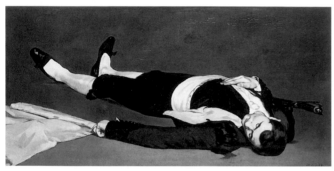

16

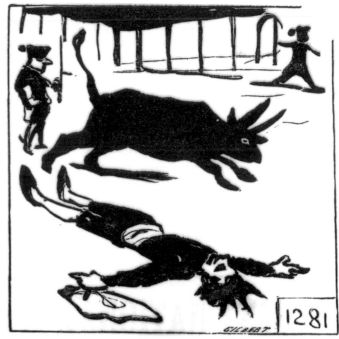

17

entirely absent from the official Salon, even though he had proposed nothing to the jury. A portrait of him by Fantin-Latour with the dedication, "to my friend Manet," had been accepted. In the assemblage of official paintings, the presence of this man in disgrace, painted to look quite civilized and smiling the subtlest of smiles, was a sort of protest made by one talent in favor of another. Wearing a top hat, with his cane held tightly in both hands, one of which is gloved, Manet is shown standing erectly, in fullface. The expression of the eyes is thoughtful, and beneath the well-trimmed beard the chin is determined. He has an ambiguous smile that seems to mock the onlooker wittily, almost good-naturedly, as though he were saying, "I'll get you yet!"

Soon he was on his way to real success. Emile Zola wrote several articles in his praise, and in 1870 Fantin-Latour painted a kind of manifesto in his favor, the **Studio in the Batignolles Quarter**, in which Manet is shown painting, surrounded by those who had taken up his defense: Renoir, Monet, Bazille, Zola, and Zacharie Astruc, the latter a sculptor and poet as well as a painter. Only Baudelaire, who had already figured in the Homage to Delacroix, was absent. When this "painted triumph" of Manet was shown in the Salon, it was the butt of many jokes, among them a caricature of the canvas entitled, "**Jesus painting in the midst of his disciples**, or **Manet's divine school**, a religious painting by Fantin-Latour," which appeared in Le Journal amusant.

Philippe Burty, whose special talent for repeating what was told him was well known, described Manet giving lessons to Eva Gonzalès, coming and going, arranging on the corner of a table a few bunches of grapes, a knife, and a slice of salmon on a silver platter. "Now do that quickly," he was supposed to have said. "Don't worry about the background, but try, above all, to reproduce the tone-values. Do you understand? When you look at that, you neither see nor look at the stripes on that paper over there. Isn't that so? Nor, when you look at the whole thing, do you bother to count the salmon's scales! You see them in the form of little silver beads on gray or pink, don't you? And how pink this salmon is, with the bone growing white in the middle and with grays like the shadows in mother-of-pearl!... But, above all, you must not overdo your shading!"

Then, suddenly, came the war, horrible man-eating war, about which Mallarmé was to say arrogantly, "I refuse to accept the fact that so many interruptions should disturb my most intimate thinking." When the Prussian invasion took place, Manet, like Degas, was enrolled as a gunner. He was later transferred to the headquarters of the National Guard, with the rank of lieutenant. (His colonel was Meissonier, the painter who specialized in soldiers and battle scenes.) Then as soon as peace was signed, he joined his mother, his wife, and Léon Koëlla-Leenhoff in Oleron, whence, via Bordeaux and Arcachon, he returned to Paris.

He soon became friends with the composer Emmanuel Chabrier, whose enthusiasm for all that was Spanish he shared. Chabrier, who always wore an open waistcoat and a shirt with a wide, turned-down collar, came every Thursday

18 **Mlle Victorine in the Costume of an Espada** 1863
Oil on canvas, 65 1/2 x 50 3/4 in.
The Metropolitan Museum of Art, New York
(Bequest of Mrs. H.O. Havemeyer, 1929, The H.O. Havemeyer Collection)

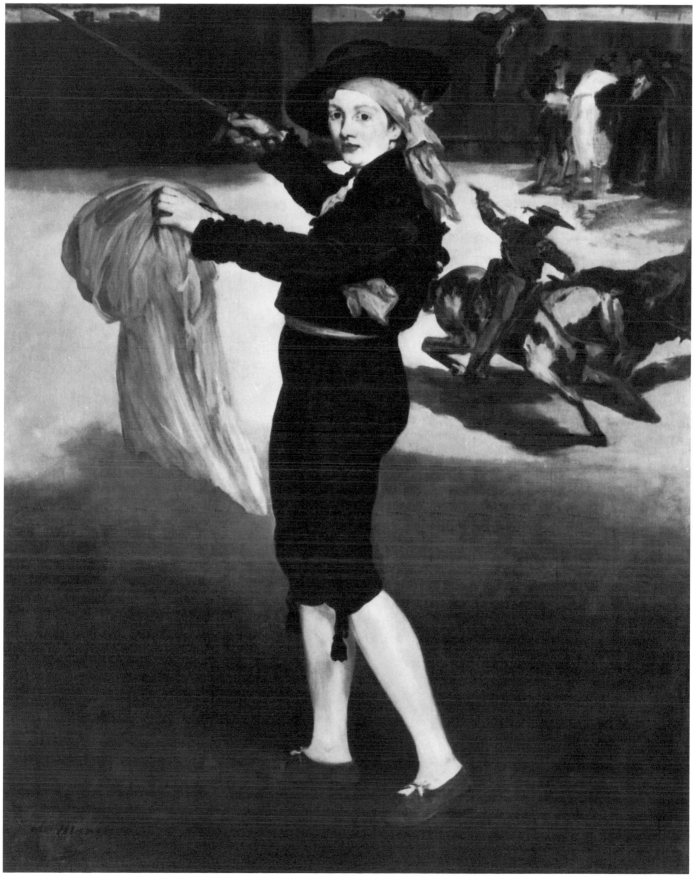

18

19 **Olympia** 1863
Pencil, watercolor, 7⅞ x 12¼ in.
Collection Stavros Niarchos (See plate, page 63)

20 **Study for "Olympia"** 1863
Red crayon
The Louvre, Paris

21 Titian: **Venus of Urbino** c. 1538
Uffizi Gallery, Florence

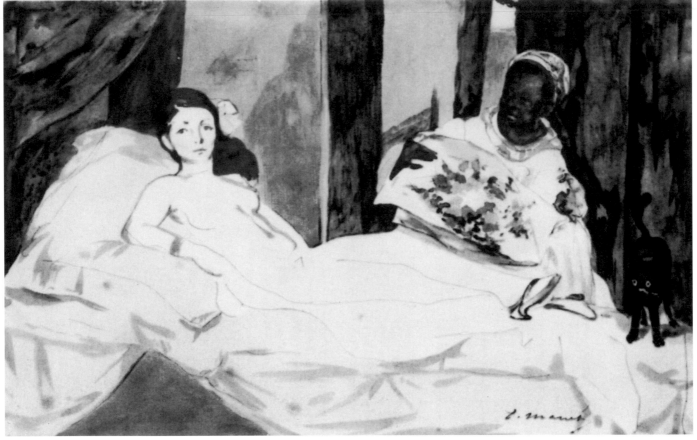

19

20

21

22 **Bullfight** 1865
Watercolor and pencil, 7 1/2 x 8 1/2 in.
Private collection, Paris

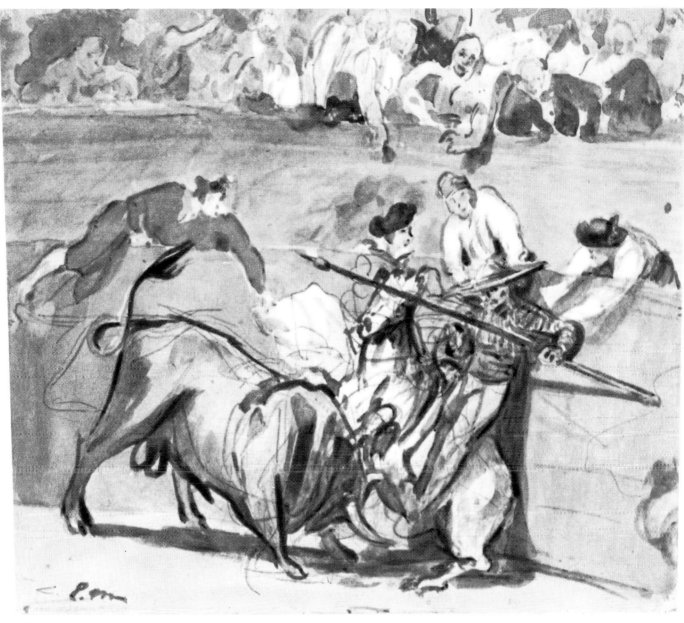

22

evening to the rue de Saint-Pétersbourg, where, singing and accompanying himself on the piano, he performed his latest compositions for the guests. Mallarmé was another good friend, and in 1876 Manet illustrated his **Après-midi d'un faune** with four drawings for wood engravings.

In 1876 **The Laundress** and the portrait of Desboutin were refused, without a word of protest, by the jury of the Salon. Manet retaliated by inviting the press to see his pictures in his studio. He wrote on his card at the door, "Do what is true and let them talk."

"Manet having announced his Salon in his own studio, four thousand persons stood in line for a fortnight," wrote Gustave Geffroy in *La République des Lettres*. It was then that he first saw **Olympia**, about which he was enthusiastic. "Everything is fine, our little friend Geffroy is on our side," was Manet's comment to Monet.

Little by little, the cabal that had been organized against Manet began to diminish in violence. Antonin Proust, who had been named by Gambetta to the Arts Ministry, and who was a former fellow student under Couture, arranged for Manet to be decorated with the Legion of Honor. "So now you have arrived," a friend said; "when Gambetta becomes President of the Republic, you will be his official painter!" Manet, who was familiar with the ins and outs of politics, replied, not without a touch of bitterness: "Gambetta? As soon as he gets to the Elysée he'll have himself painted by Bonnat!"

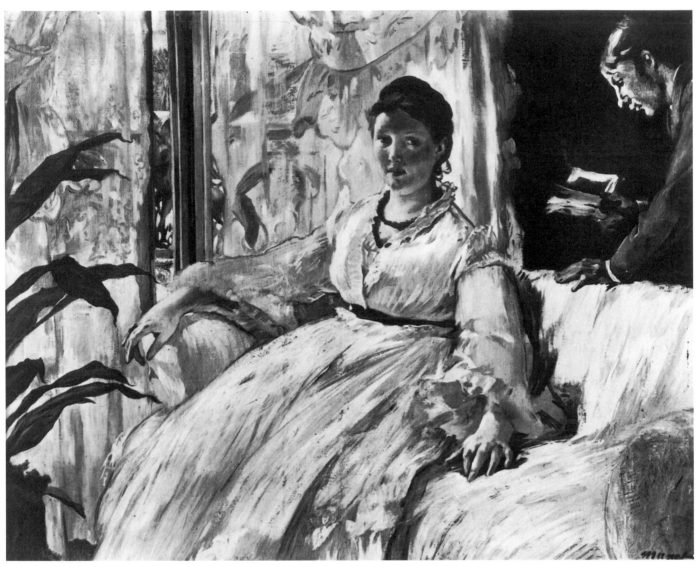

23

In order to take a treatment of hydrotherapy, Manet rented a house in June 1880 on the route des Gardes in Bellevue, where he spent three months. Back in Paris he resumed his feverish existence with its numerous receptions. Then, weary, tormented, and suffering from locomotor ataxia, he went to Versailles for a rest in a house with a garden. There he still worked a great deal, executing many portraits in pastels. But despite excellent care, he began to grow weaker. An attack of phlebitis forced him to use a cane in order to walk around the little garden of the house he rented in Rueil. An futile attempt to prolong his life was made by amputating his left leg, which was infected with gangrene. He died several days later, on April 30, 1883, at seven o'clock in the evening, in the apartment situated at 39, rue de Saint-Pétersbourg. Emmanuel Chabrier was at his bedside.

In the print department of the Bibliothèque Nationale, I was able to consult the family album in which Manet kept his photographs. The collection opens with photographs of Manet in his extraordinary waistcoats; there follow many other pictures of his family, friends, and sitters. For portraits of people so busy that they could spare only a few hours for sittings, Manet used photographs, to which he adapted the pose. For example, Clemenceau, whose photograph we see here, had his portrait painted at a crucial period in his career, in 1880, when as deputy for Montmartre, he was about to found *La Justice*.

This picture of a bearded man with the long hair of an artist is the sculptor Ferdinand Leenhoff, Manet's future brother-in-law, whom he painted in **Luncheon on the Grass**. (Leenhoff was twenty-two at the time.) Next comes Faure, a famous baritone at the Opéra and an important Manet collector, whom he painted in all his different costumes;

24 **Portrait of Line Campineanu** 1878
Oil on canvas, 22 x 18 1/2 in.
Nelson Gallery-Atkins Museum (Nelson Fund) Kansas City, Missouri

25 Goya: **Flower Girls** (detail) 1786
The Prado, Madrid
The pictures on these two pages suggest Manet's admiration for
Velázquez' and Goya's techniques and approaches to subject matter.

26 Velázquez: **The Maids of Honor** (detail) 1656
The Prado, Madrid

24

25

26

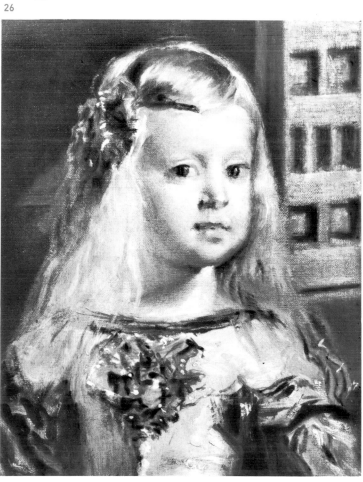

27 **Civil War** 1871
India ink and watercolor, 18 1/8 x 12 5/8 in.
Museum of Fine Arts, Budapest

28 **The Barricade** 1871
Lithograph, 18 5/8 x 13 3/8 in.
Prints Division, The New York Public Library

29 Goya: **The Third of May, 1808** 1814–15
The Prado, Madrid (See also plate, page 75)

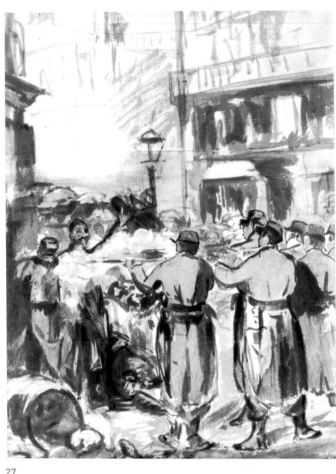

27

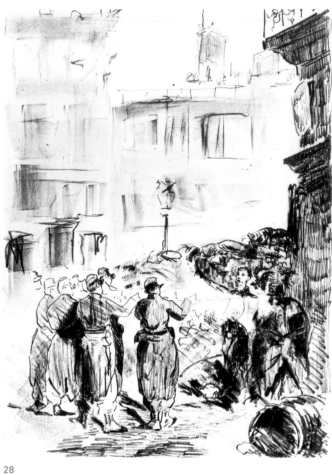

28

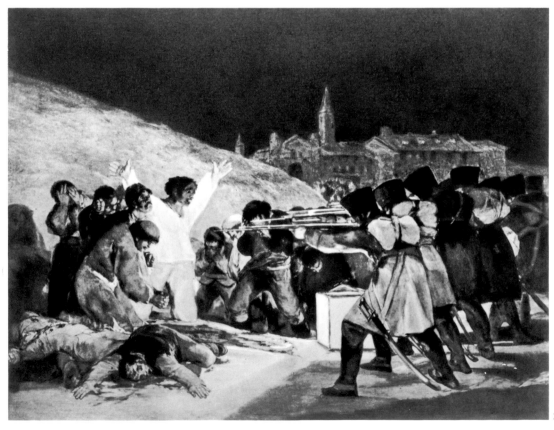

29

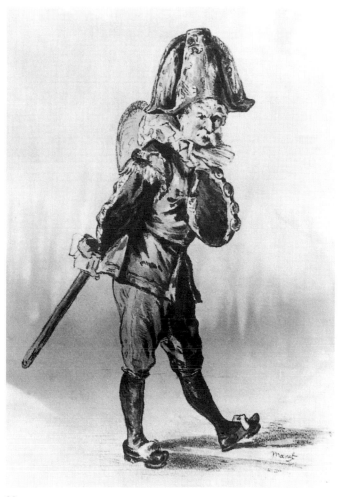

30

then we see Abbé Hurel, a friend of the family; Jules Dejouy, a barrister at court; the polemical figure of Rochefort, a terrible Communard, whose escape from Nouméa on a small boat Manet also painted; and finally young Léon Koëlla-Leenhoff, the lad in the straw hat who stands facing us in **Luncheon in the Studio**.

Next, in bustle skirts, in négligées, or in all their finery, come the women—relatives, sweethearts, or models. Time has brought them all together now and forced them to mingle between these pages. Can this nice, plump profile be Méry Laurent? I am not sure. And this rather gaunt brunette, with eyes like live coals, immersed in the reading of a poem? Could she be Baudelaire's friend, the "Black Venus," whom he brought to Manet's studio around 1863? But let's come back to those we know for sure. Here are Miss Claire Campbell, whose father ran the *Daily Telegraph*; Mme de Loubens, in bed, as Manet painted her; Marguerite de Conflans, one of whose portraits is in a similar pose, resting on one elbow; the buxom Eva Gonzalès; Mme Brunet, née de Penne, the wife of a sculptor of busts and medallions,

who posed for the **Woman with Glove** and the **Street Singer**. Indeed, an entire epoch with its heterogeneous society may be glimpsed in this book, in which Manet has doubtless left hidden forever many secrets of his own.

What was there so special about this painter who was accused of wanting to break with traditional rules and all that in his time was called great art? Painting was still directly indebted for its sustenance to the Italian Renaissance or to antiquity, and art was expected to avoid all reference to the sordid spectacle of life and reality. Manet, on the other hand, although he continued to borrow from the classics (his quotations from Carracci, Marcantonio Raimondi, Titian, and Goya have already been pointed out), introduced changes in both presentation and technique. For this reason, his art was a target for numerous jibes and base attacks which to us seem quite incredible. Indeed, he was mocked as no painter had ever been. Duret recounts that such epithets as "barbarian," "renegade," and even "bad patriot," were hurled at him.

All this wounded without utterly discouraging him. For, as Burty says, "he was endowed with an essentially French nature, and answered malice with a jest that, while it could be sharp, was never poisonous." He let the showers pass with a smile and "believed in himself with convincing naïveté." "This war of daggers," he admitted one day, "has done me a great deal of harm, and I have suffered intensely from it. But it was also a stimulus for me. I would not wish any painter praise and flattery from the very start. That would mean destruction of his personality."

There were, however, some consolations. Baudelaire understood him, Zola defended him, and he was surrounded by a group of young Impressionists. He also had the future on his side. When Jacques de Bietz, calling him a virtuoso of the solfeggio of values, wrote shortly after his death in *Le Voltaire* of May 2, 1883, "Now that Manet has been decorated and made a medal-winner by the Salon jury, official art has been beaten on its own ground," it was true. For damned though he was, he has had a veritable retinue of followers and admirers: *Manet et manebit*.

"This rebel," Zola said of him, "had always dreamed of the kind of success that only Paris can give, with the compliments of women and adulatory welcome to the various salons." But, as it happened, he was forced to compel recognition through boldness. No doubt it was just this audacity which appealed to Baudelaire, who never ceased to be astonished by the vulnerability of his blond friend in the face of criticism. But eventually all this subsided and today what distinguishes Manet from other painters is above all the mysterious quality of his surfaces, the incomparable touch that characterizes certain of his paintings. If this brio were merely superficial rather than an inherent subtlety in Manet's

31 **Mme Manet on a Blue Sofa** 1874
Pastel, 19 1/4 x 23 1/2 in.
Museum of Impressionism, The Louvre, Paris

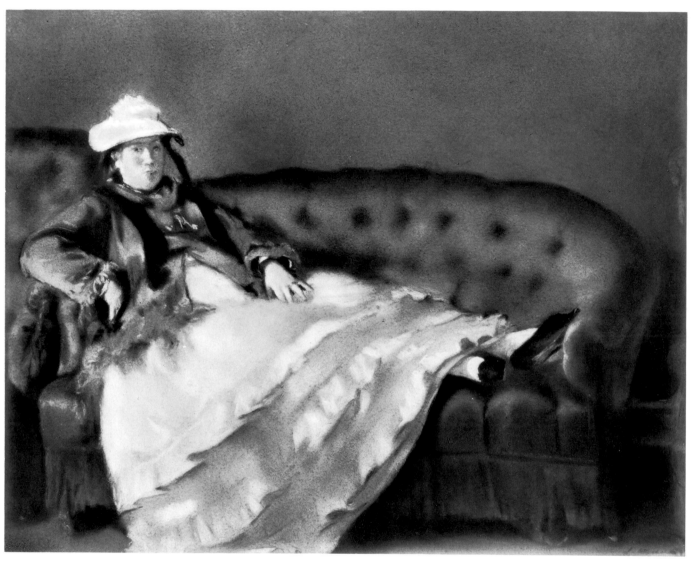

31

nature, he would be another Chaplin, "a successful painter of languid flesh." Then again, if his touch were heavier or a little harder, he would not be far from Carolus-Duran or Bastien-Lepage. How did Manet succeed in stopping just in time? As a result of what minute nuance was he able suddenly to outstrip all of these mediocre painters? Actually it is an infinitely fine distinction, the firm shading of an outline, the quality of a tint applied to a bodice, the evidence of his lights and shades.

Manet is indebted to Constantin Guys—in comparison to whom his rounded drawing occasionally looks like a tracing with no suggestion of volume—for the sensuality of his line. In the beginning, his choice of subjects was not unusual. His real charm does not lie in the somewhat theatrical paintings of characters recruited from the Polish quarter, tricked out in rags, and served with *"sauce musée"* under borrowed

titles like **Old Musician**, **Beggar**, or **Drunkard**. In these pictures he was still paying tribute to realism. His originality, so obvious in the roguish smile of the **Boy with Cherries**, seemed destined for a short life, since it is scarcely evident in **Le Bon Bock**, that astounding work of craftsmanship. Indeed, I feel sure that neither Delacroix nor Courbet would ever have succeeded in bringing such a piece of virtuosity to so brilliantly dangerous a point.

It must be admitted that Manet is a rather uneven painter, quite capable on occasions of losing himself in the pleasant comfort of a bunch of peonies for dining room panels. From this standpoint a comparison might be made between the too carefully painted Manets, such as the **Child with Sword**, and certain rather contrived landscapes by Corot. It would be interesting to confront these "pieces" and these "views" with the best works of both painters, such as the **Douai Belfry** and

32 **Woman with Fans** (Nina de Callias) 1873-74
Oil on canvas, 44 1/2 x 69 1/4 in.
Museum of Impressionism, The Louvre, Paris

33 **Portrait of Nina de Callias** 1874
Ink and gouache on wood block, 3 1/2 x 2 3/4 in.
Museum of Impressionism, The Louvre, Paris

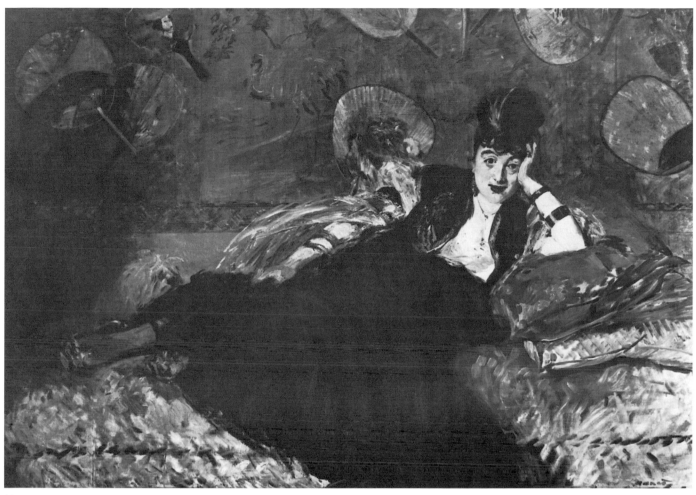

32

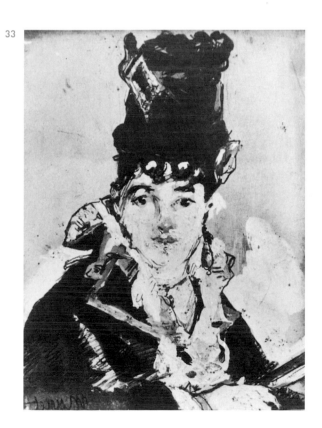

33

the **Ballet Espagnol**. Baudelaire had noticed these moments of weakness in Manet, which he referred to as "*lacunae* in his temperament."

In any case, it is certain that Manet lacked the felicitous evenness of a Delacroix. His break with "good taste" was also less conscious than had been supposed, for it was a break that had taken place, above all, from the outside, in his choice of subjects that were shocking to contemporary bourgeois opinion: the nude woman surrounded by clothed men in **Luncheon on the Grass**; the theme of the still pubescent prostitute in **Olympia**. In technique (leaving aside the renewal brought about by open air and light), Manet sought to give a rather traditional impression. I say "sought to give" for the reason that there existed in Manet, as in the visionary painter of **Algerian Women**, a certain discrepancy between his intentions and the results obtained, and at his moments

34 **Berthe Morisot with a Fan** 1874
Watercolor, 8 1/4 x 16 1/2 in.
Private collection

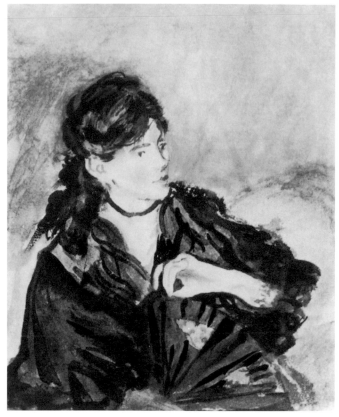

34

of genuine inspiration, which were also his moments of innovation, good taste and the desire to please were dominated by the unconscious. In fact, his most convincing work was done purely instinctively.

But enough of these critical shadows. Let us rather look at the complicated clarity of what we believe to have been the secret of this unwitting revolutionary. For when he was dominated by his passion, Manet, whose imagination was limited to that of nuance, could suddenly rise to great heights of vision. At these moments he is unexcelled. Indeed, these values, which seem to be composed of the most exceptional sights to be seen in this City of cities, are like a caress to the eye, for there the skin of his painting becomes apparently as sensitive as an iris behind which life itself is palpitating. The spectacle of city life, the reflection of a veil multiplied by brilliant water, the delicate profile of a "boulevard butterfly" like Jeanne de Marsy, a special way of tying the strings of a picture hat or of capturing the gleam of a satin skirt, certain adorably bluish and melancholy pinks, the washed-out blond of a straw yellow—all, not without a touch of the picturesque, help us to understand the attraction exercised in France, and especially outside France, by the painting of this Frenchman. Manet is the depository of a certain charm and bears within himself an inimitable gift that makes people exclaim, "Ah,

that is Paris!", the way they once spoke of the golden age, or Arcadia.

Manet is undoubtedly a painter who brings with him the nuance of the sky above the Seine, as well as the perfume of the women to be met strolling along its banks. His touch is that of the Île-de-France itself.

Although it is legitimate to say that the painter of **The Laundress** paved the way for the Impressionists, to whom he is at times closely related, one can also say that he differs from them, and even that he is opposed to them. In his concern with visual sensations, in his delight in colored patches whose representational motives he occasionally forgot, and in the fact that through his intoxication with natural light he achieved a perfect unity between his subject and the atmosphere in which it originated, Manet is an Impressionist. Berthe Morisot noted this in a letter, "Edouard often said that he made a fresh study of his environment for each picture that he painted. This sincerity and impressionability with regard to nature, are what give such charm to his work." Manet also deliberately took painting out of the dark Barbizon studio, established it firmly in the open air, and dared to make oppositions of vivid, saturated colors. But— and this is wherein he differs not only from a painter like Seurat, but also from a Pissarro or a Monet—he neither analyzes nor breaks up his light, but paints in broad planes of color that stand out in their contrasts. To intensify the light he spreads it in sheets within the contours of his forms, simplifying details to the extreme. This is the technique of the **Fifer**, from which all shadows are banished, and in which, throughout, the lights are equally pale in tone. Manet paints light with a felicity and an increasingly intense joy. In his maturity, he achieved a touch that was limpid, sure, subtle, naturally sensitive, even brilliant, always discriminating, quivering in the greens of nature, delicate on flesh, trembling and stressed on portraits, applied, finally, as an adieu, in the bouquets painted in the rue d'Amsterdam room that he was not to leave again. Here he communicated an irresistible emotion with a rose, or a hurried punctuation with a sprig of lilac. He felt an ephemeral communion with flowers.

Occasionally Manet was carried away. At these moments, he made quick, sharply accentuated little brush strokes that flashed and danced and swirled without ever being mannered. Jacques-Emile Blanche has paid fitting tribute to "his touch, which is at once precipitate and considered; the extreme care with which he surrounds his outlines, toiling, effacing, then starting over again, until the surface has become pure and lovely, thus conferring strength and cleanness, something that is definitive, upon the picture.... Manet knows how to begin again without soiling his canvas." And Blanche adds, "the flower of his palette does not fade."

35 **Young Girl on a Bench** 1878
Pastel on canvas, 24 x 19 3/4 in.
Collection Mrs. Marshall Field, New York

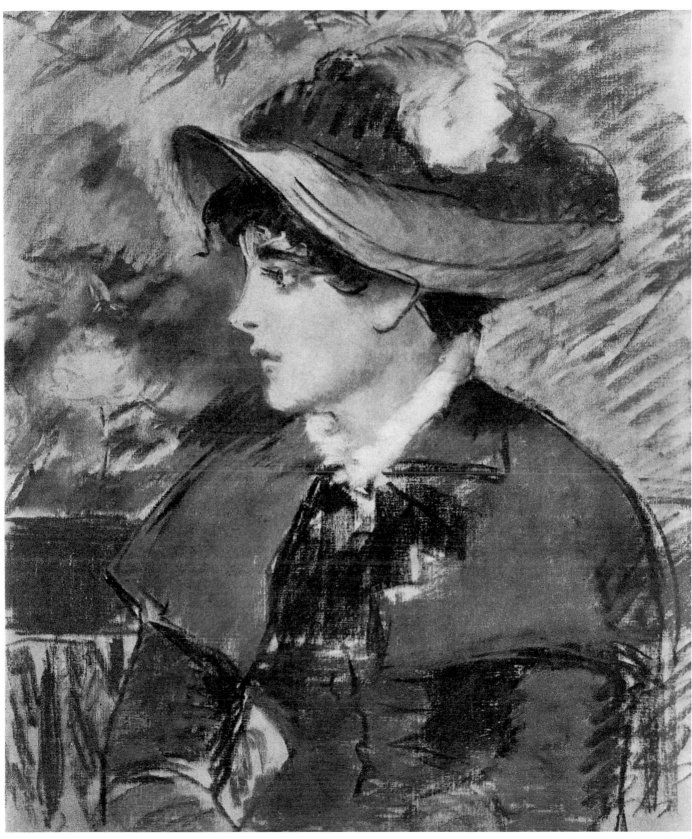

35

36 **Woman with a Fan** 1872
Oil on canvas, 23 1/2 x 17 3/4 in.
Museum of Impressionism, The Louvre, Paris

37 **Portrait of a Woman** 1880
Pastel on canvas, 21 x 17 1/2 in.
Museum of Impressionism, The Louvre, Paris

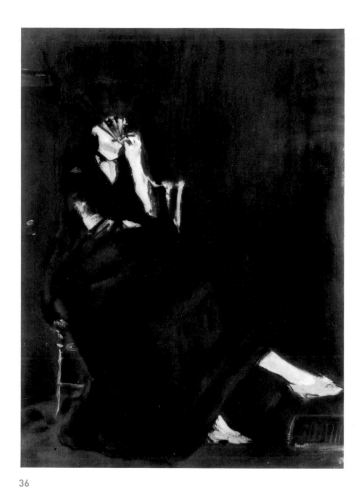

36

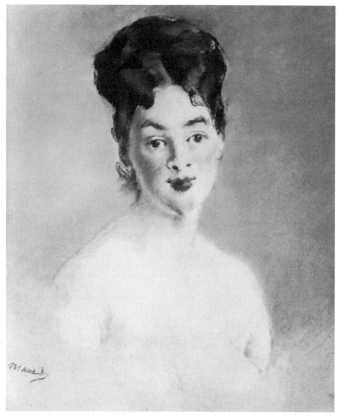

37

This palette of Manet's, whose vividness is matched only by that of Velázquez when he paints an infanta with a bouquet, has the refinements of a coquette and the cunning of a butterfly. There is something irresistibly attractive about its exquisite cleanness. It is impossible to convey in words its radiant intensity, its yellowed poppy-reds, its acid foliage beneath which there suddenly appears the brilliance of a scarlet geranium, its greens of a watering-can or a painted shutter.

In his earth pigments too, Manet is no less enchanting, with his warm grays and mouse-colored or greenish shadows; and as for his whites, it is as though they had been scoured by sunlight, rumpled by feminine hands, and given a slightly bluish tint as a result of laundering. From having been milky at their palest, they vary in tone, grow blue or take on the flesh-pink of **Olympia**. Her face, as J.-K. Huysmans said on the day that he became converted to Manet's painting, contains something "fixed and bafflingly enigmatic."

But all of that would be nothing were it not for the color harmonies that kindle and intensify the lyrical quality of Manet's painting. What exactly is this color? Manet knew how to obtain from black, the famous black that was to disappear temporarily from the palettes of the Impressionists,

an infinite number of varieties, from the satiny black of a workman's blouse to the mat, vivid black of a velvet jacket. Here we have the lacquered black of a tray with a lemon on it, there the tufted black of a toreador's toque. Turned gray on a beggar's old clothes, black is used as well to make up the eyes of the Spanish dancer. It becomes dull on the swallow-tailed coats of the guests at the Opera Ball, and then it tends toward ebony and blue about Berthe Morisot's face, before becoming cinder-colored on the eyebrows of a feminine profile, and finally disappearing entirely from the last paintings.

Manet's paintings are rarely tragic; they contain little suffering or Christian drama, despite the **Dead Christ with Angels** and the numerous Tiepolo-like drawings of monks that exist in the Louvre archives. Death, which was such an obsession with Gericault, appears only a few times in his work, suggested by the black silk of an accident (**Dead Toreador**, **The Suicide**,) or by an act of vengeance (**Execution of Emperor Maximilian**). This man fascinated by brushwork, this painter of the exterior, evokes on another level a different kind of reality. The subtle naturalism and "sympathetic irony" of the man of taste finally take on something of the

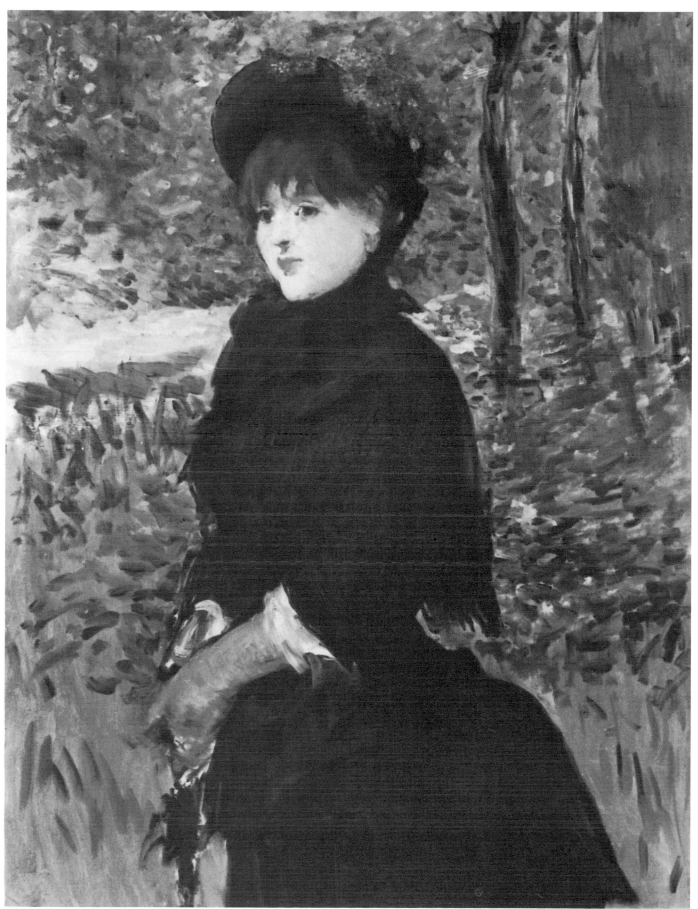

38

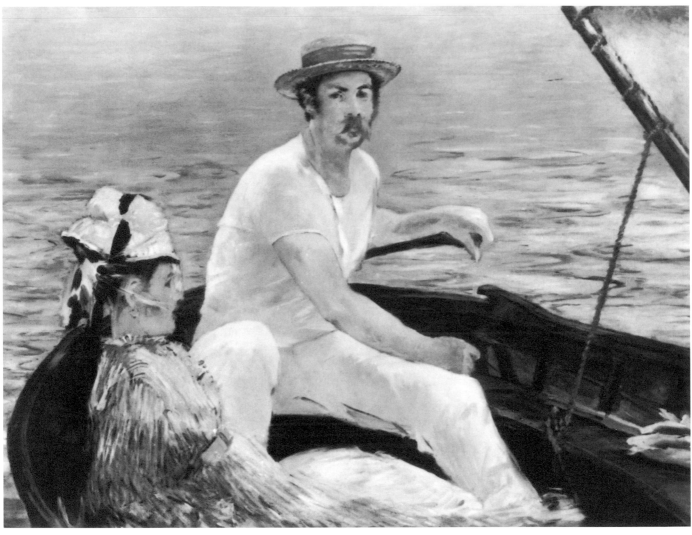

39

luminous sparkle and lofty crystallization of Mallarmé, who sought in the blue vault of the sky to "forget cruel ideal and sin," only without the uneasy difficulties and hermetic transparencies of the poet's thinking.

This wide gulf from Zola to Mallarmé, which Manet alone bestrides, helps us to understand in what respect the brilliant freshness and absolute purity of his manner of seeing and making others see can be so intoxicating. We know many other portraitists of appearances. Not one, however, unless it be Velázquez, has surpassed the appeal that a flower on a bodice can make in a work by Manet. What other painter before Renoir has so magnified life as it appears to the passerby? Ingres stops at the eroticism of seeing without conveying in his paintings the color inherent in his marvelous drawings; Delacroix is constantly inquiring, tormented by the meaning of existence and the need to increase his stature; Courbet never manages to escape from the atmosphere of

his native rocks and streams, which in the end he merges with his own identity. Manet is a curious mixture of ingenuousness and criticism—but not the bitter criticism that kills emotion in Degas or overflows with contemporary references in Toulouse-Lautrec—and with the mixture of these two elements in his nature he becomes the incarnation of charm.

We understand now why this apparently facile art, confined within the incompleteness of reality, can fascinate us so. For superimposed on certain of his paintings—on **The Tipsy Woman**, for example—there is an ineffable harmony, the vibration of an imponderous joy. Through the complete absence of any sense of guilt, or even of fatality, his work radiates an extraordinary innocence.

Manet's sense of the abstract moment of duration, and the unquestionable clarity of the image, free from deep pathos, had an undoubted attraction for Paul Valéry, himself a poet vanquished by the sparkling "nothingness" of his

40 **The Croquet Match** 1873
Oil on canvas, 28 3/8 x 41 3/4 in.
Städelsches Kunstinstitut, Frankfurt am Main

41 **Swallows** 1873
Oil on canvas, 25 5/8 x 31 7/8 in.
Formerly collection Hecht, Paris

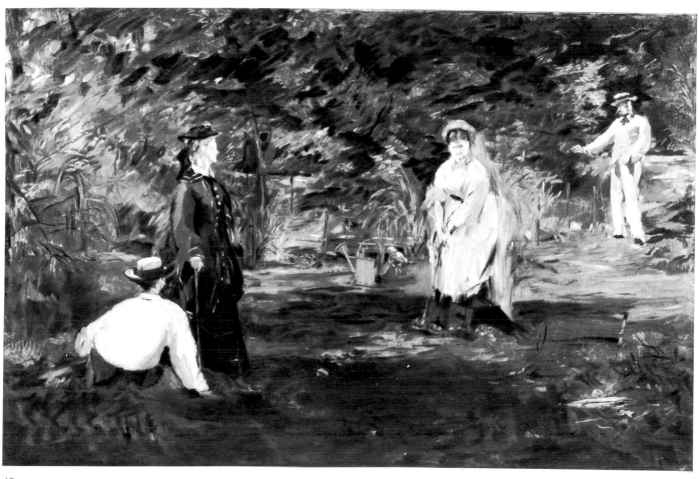

40

41

42 **Le Bon Bock** 1873
Oil on canvas, 37 x 32 5/8 in.
Collection Mrs. Carroll S. Tyson, Philadelphia

43 **Woman with a Garter** 1878
Pastel on canvas, 21 5/8 x 18 1/8 in.
Charlottenlund-Copenhagen, Malerisamlingen paa Ordrupgaard

44 **The Suicide** 1877
Oil on canvas, 14 x 18 in.
Collection Emil G. Bührle, Zurich

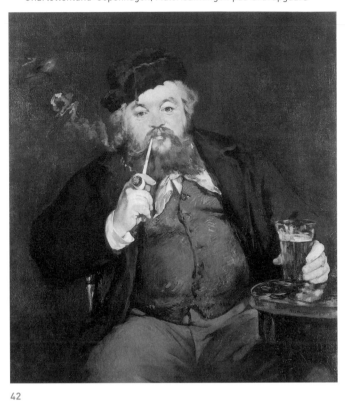

42

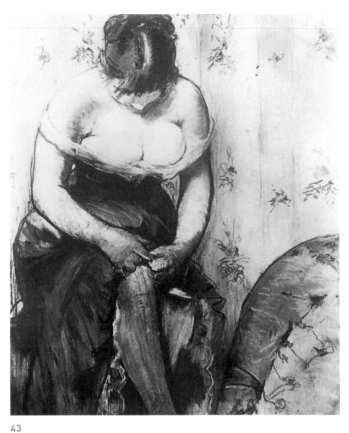

43

44

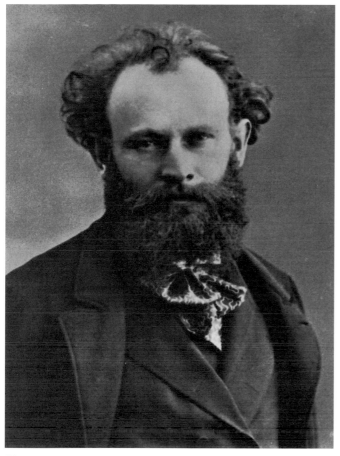

45

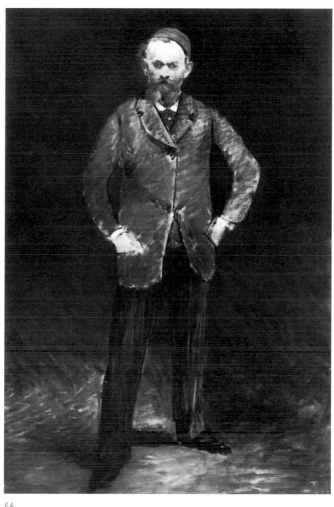

46

solitary person. But whereas Valéry would appear at times
to suffocate in a closed circle, Manet remains open; his light
is a source of present delectation without guilt, without a
hint of the funereal or baleful. Manet's entire work is bound
up with the pictorial moment. As Huysmans wrote, he
"envelops his figures with the perfume of the sphere in which
they belong" and then comes to a halt before reaching the
very brink of knowledge in a self that accepts life as it comes.

"Enthusiastic, elastic and theatrical" was what Fénéon
said of him. But this last adjective seems to me to be some-
what spitefully superfluous. Manet theatrical? Hardly spec-
tacular even, at a time when Gustave Moreau's mythological
imagery was paving the way for symbolism. It seems to me,
on the contrary, that Manet's work is stripped bare, com-
pared to the man who later became the teacher of Matisse
and Rouault. Under the guise of banality, Manet's painting
appears in all its spirited, animal youth; there is no mirror
to be penetrated. For Manet was entirely absorbed by the joy
of painting and lost himself in it entirely. This joy, merely

because he was there to experience and transmit it, seems
to have been all he demanded of life.

A master of the psychology of color, who was able to
transfix movement at the instant of its aerial mutation,
Manet was not a painter of impressions, but of composed
instants. In his art, he had an intuition of time according to
its emotional importance, which made him greater than
most of the Impressionists who followed him, for whom time
only existed outside man in the luminous, spaced procession
of hours on things. This fact, despite his evident unevenness
and the small number of works in which his essential
qualities are fully present, explains Manet's extraordinary
importance for his century.

I like Manet when almost nothing remains of the enter-
taining or merely pleasing subject, nothing but a café table
and on it a woman's hand beside a glass; when there is only
Lola's "pink and black jewel," or the gray and blue patches
of a couple stretched out on the sand, or a dialogue between
pink and green. This is the real Manet; this is his trembling

47 **Portrait of Clemenceau at the Rostrum** 1879–80

48 Georges Clemenceau, from a photograph

49 **Portrait of Rochefort** 1881
Oil on canvas, 32 x 26 1/8 in.
Kunsthalle, Hamburg

50 Henri Rochefort, from a photograph

47

48

49

50

51 **Women Drinking Beer** 1878
Pastel on canvas, 21 5/8 x 18 1/8 in.
Art Gallery and Museum (Burrell Collection), Glasgow

52 **Serveuse de Bocks** c. 1878–79
Oil on canvas, 29 1/4 x 25 1/2 in.
Museum of Impressionism, The Louvre, Paris

53 **Model for the Barmaid in "Bar At The Folies-Bergère"** 1881
Pastel on canvas, 22 x 14 1/8 in.
Museum of Fine Arts, Dijon

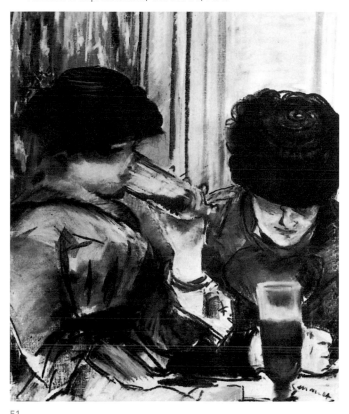

51

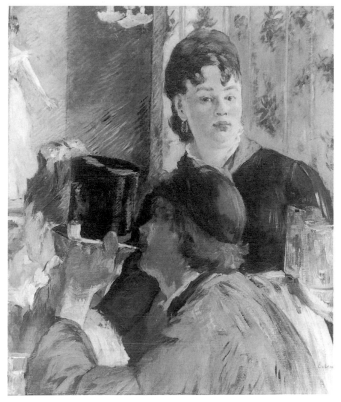

52

53

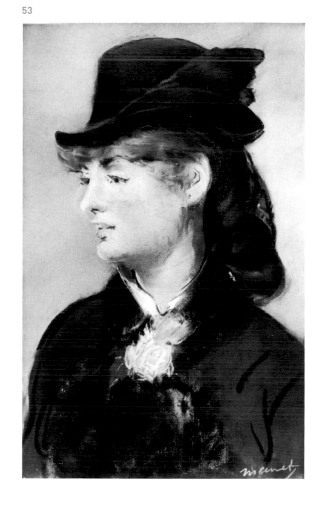

sensibility and his gift of touching upon the surface of things, in a substance as crystal clear as the soul's own light.

"He was greater than we thought," said Edgar Degas after his friend's funeral. But did Manet have to die before his work could reveal him as he truly was, "as eternity had finally changed him into himself"? Was this really necessary? I believe that it was. Representing a unique accord of *savoir-faire* and poetry, Manet is now triumphant, irrespective of history, in the unchallenged, unbroken moment that is his painting. Now he lets us see things, gives himself up entirely to this brilliant space. But it is space inhabited by mankind—it is the poetry of space in painting.

54 **A Café on the Place du Théâtre-Français**, 1881
Pastel on canvas, 12 5/8 x 17 3/4 in.
Art Gallery and Museum (Burrell Collection), Glasgow

55 **A Bar at the Folies-Bergère** 1881
Oil on canvas, 18 1/2 x 22 in.
Boymans Museum, Rotterdam

56 **Isabelle Lemonnier** 1880
Watercolor, 7 3/4 x 4 3/4 in.
The Louvre, Paris

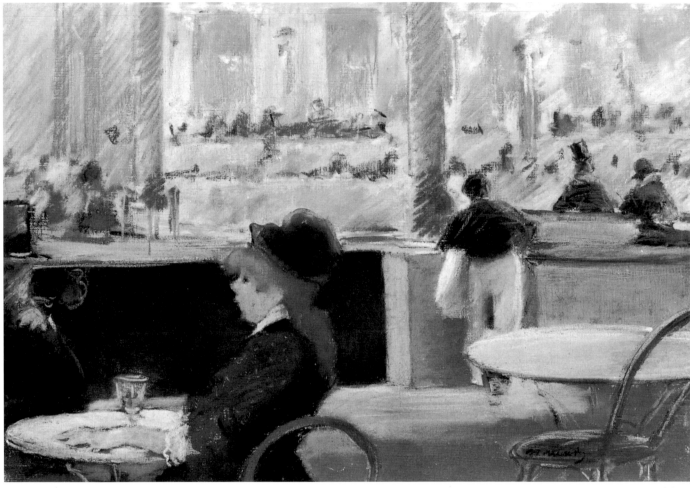

54

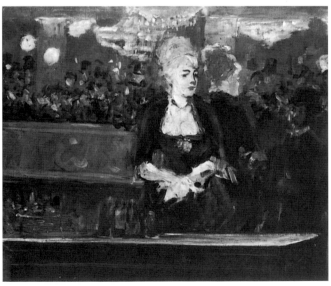

55

56

sketches, drawings

and prints

57

58

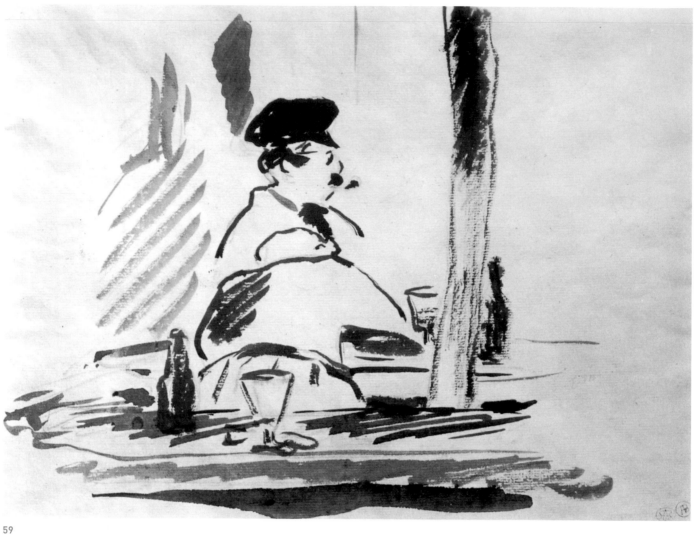

59

60 **The Orchestra** 1878
Wash and pencil, 8 1/2 x 10 7/8 in.
The Louvre, Paris

61 **Women's Legs** 1876–78
Pencil and wash, 7 1/4 x 4 3/4 in.
The Louvre, Paris

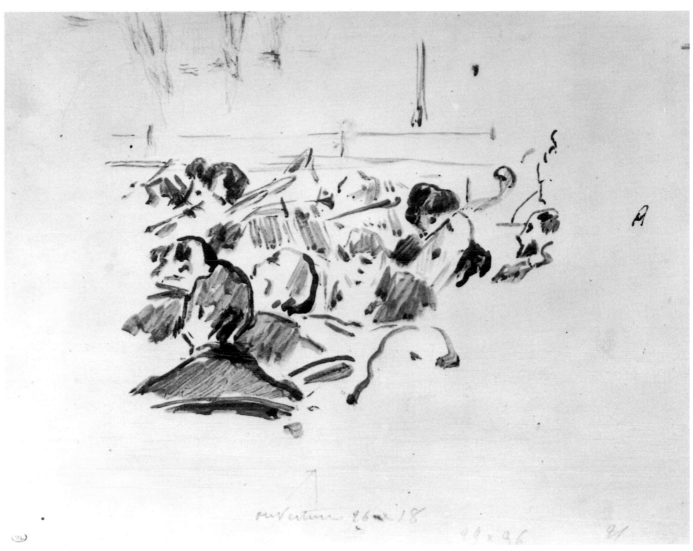

60

61

62 **The Races at Longchamp** 1864
Lithograph, 14 3/8 x 20 1/4 in.
Bibliothèque Nationale, Paris

63 **Portrait of Baudelaire** c. 1860
Etching, 5 3/4 x 3 in.
Bibliothèque Nationale, Paris

64 **Sketch of a Watering Can** c. 1880
Wash, 8 x 5 in.
The Louvre, Paris

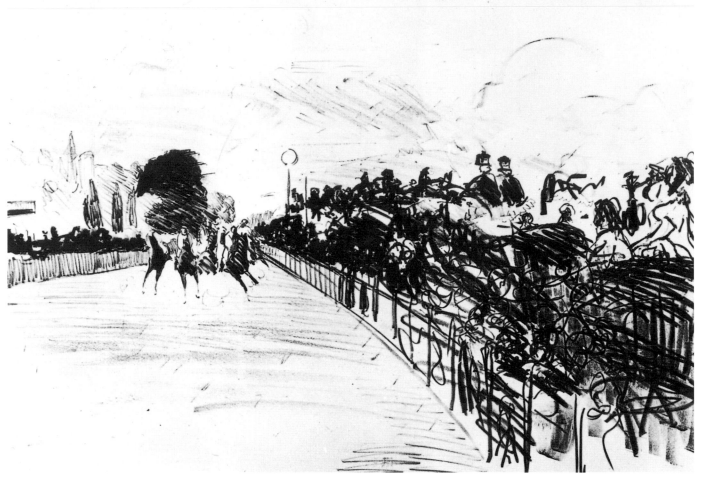

62

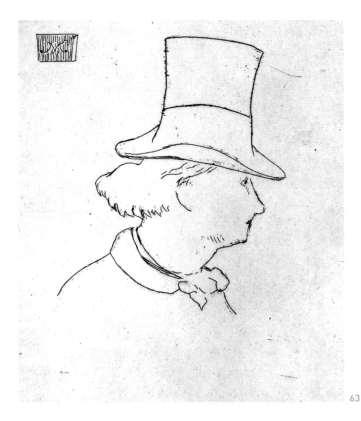

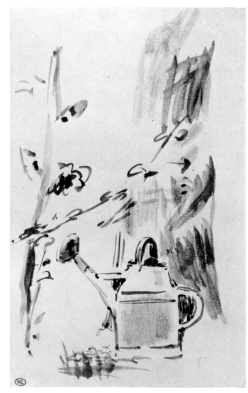

63

64

65 Etching for *Le Fleuve*, poem by Charles Cros 1874
3 1/8 x 5 1/8 in.
Bibliothèque Nationale, Paris

66 **Le Rendez-Vous des Chats** 1869
Lithograph, poster for Champfleury's *Le Chat*
17 1/4 x 13 1/8 in.

65

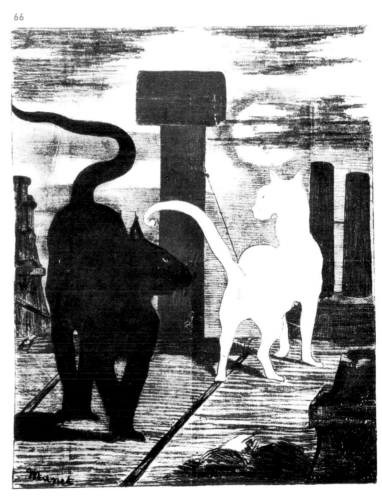

66

67 Illustration for Poe's *The Raven* 1875
Lithograph, middle state, 17 1/2 x 13 3/4 in.
Bibliothèque Nationale, Paris

68 Illustration for Poe's *The Raven* 1875
Lithograph first state, 19 x 13 7/8 in.
Bibliothèque Nationale, Paris

69 Preparatory drawing for the frontispiece of Baudelaire's
Les Fleurs du Mal
Ink, 10 x 12 1/4 in.
Bibliothèque Nationale, Paris

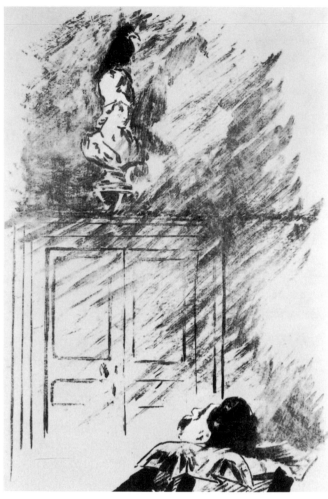

67

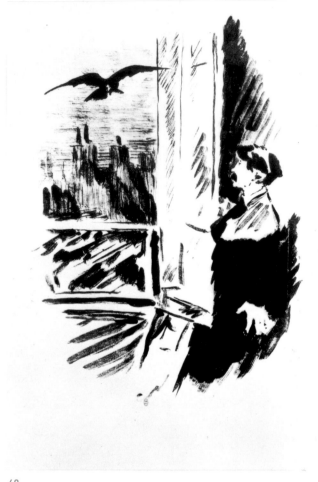

68

69

70 **The Faun** 1876
Wood engraving for *L'Après-midi d'un faune* by Stéphane Mallarmé
Bibliothèque Nationale, Paris

71 **Nymphs** 1876
Wood engraving for *L'Après-midi d'un faune*

70

71

72 **Dragonfly** 1874
Etching for *Le Fleuve* by Charles Cros
Bibliothèque Nationale, Paris

73 **Cat Under a Chair** c. 1869
Ink and pencil, 9 7/8 x 5 1/8 in.
Bibliothèque Nationale, Paris

72

73

plates

Painted c. 1858–59
25 3/4 x 21 1/2 in.
Calouste Gulbenkian Foundation, Lisbon

Boy with Cherries

This is a delightful study, still in the old style. The figure of the boy stands out against a dark background, but a close examination of the painting of the face and hands shows those generous, luminous flesh tints which were to reappear later in the **Fifer**. Though classical in tendency, Manet's treatment here displays the glowing blond texture that he gave to flesh in all his later work and that finally characterized his painting in general.

The model for this picture inspired Baudelaire's prose poem *"La Corde"* in *Spleen de Paris*, which first appeared in *L'Artiste*. The boy, whose name was Alexandre, was fifteen. Manet had engaged him to clean his brushes and palette and occasionally to pose for him. Alexandre was subject to fits of depression. One evening, Manet called him in vain. He eventually found him—he had hanged himself in a corner of the studio in the rue Lavoisier that Manet shared with Albert de Balleroy. Distressed by this suicide, Manet went in search of another studio and found one at the Place Clichy. As he went in however, his eye was caught by an enormous nail protruding in sinister fashion from the plaster. "Who hanged himself here?" he asked jokingly. "How did you know?" exclaimed the concièrge in amazement. Manet turned on his heel and fled without inquiring further.

This boy, who also posed for **Boy with a Dog**, is immortalized by the bright, youthful smile Manet has given him. The hand clutching the cherries displays that characteristic treatment, bold and darkly outlined in places, which was to be found thereafter in all the hands painted by Manet.

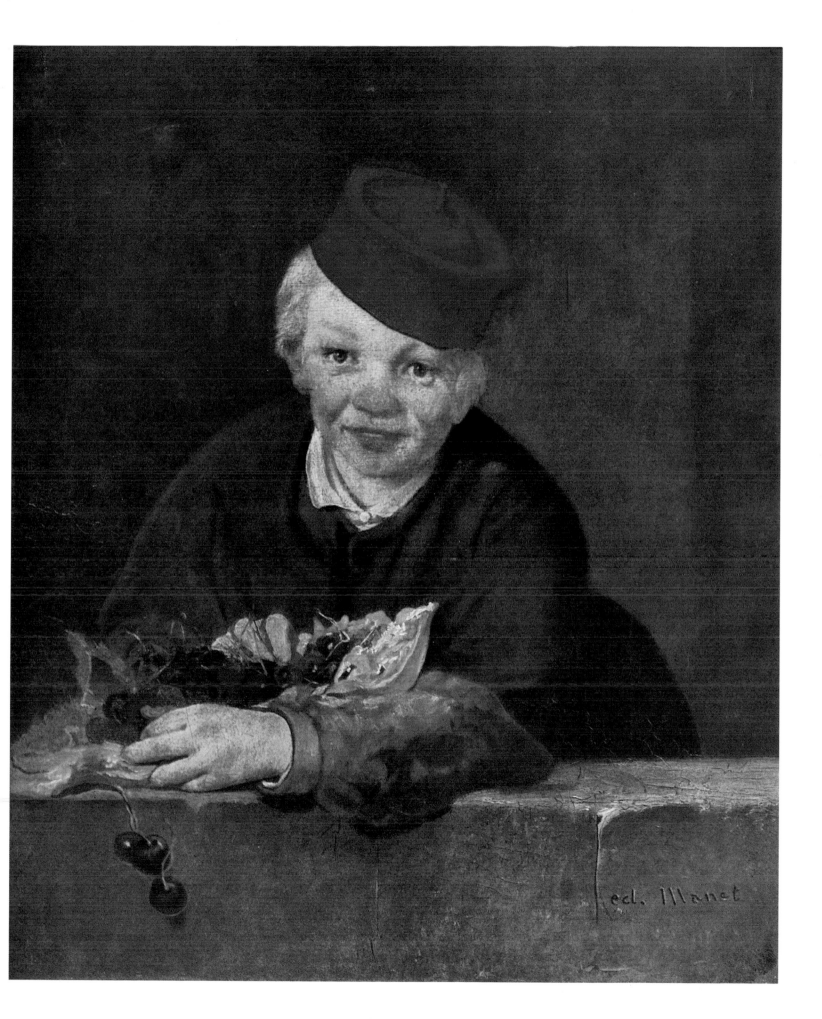

Painted c. 1860
30 x 46 1/2 in.
The National Gallery, London

Music in the Tuileries

To my mind this painting has the importance for its period that Renoir's **Moulin de la Galette** (1876) was to have for its own epoch. Certain admirable features in this canvas strike us immediately: the exquisite gradations of tone, the general harmony, and above all, the way in which the artist has shown his figures on several different planes. It is a remarkable crowd study. The artistic society of Paris during the Second Empire as seen by one of the avant-garde is before us, taking the air under the trees.

Manet painted this picture in the Tuileries late one spring. (According to Tabarant, the date 1862, which is in a different color, was added later.) "Curious passersby stopped to watch the elegantly dressed artist prepare his canvas and proceed with his painting," wrote Antonin Proust. At that time Baudelaire was Manet's constant companion. "He plasters it on," Manet used to say (it was at the time when Baudelaire used to make up his face outrageously), "but what genius lies beneath!" Baudelaire was in fact the instigator of this modern study, and it is thought that he inspired its general tonality.

Several of the people in the painting are recognizable. Manet's friend Albert de Balleroy, a painter of genre and hunting scenes, stands at the left wearing a monocle; behind him, at the extreme left, we catch a glimpse of Manet himself. Zacharie Astruc, critic, poet, and sculptor, is seated slightly further back, and the man behind him with the moustache, seen in three-quarter view, is the journalist, Aurélien Scholl. Moving to the right, we next see Fantin-Latour, facing outward, then Baudelaire in profile, the bearded Théophile Gautier, and Champfleury. The seated lady who wears a veil and holds a fan is Mme Le Josne, the wife of a senior officer, while the woman in a blue hat is Mme de Loubens, the wife of a master from the school in the rue de Rocher. Eugène Manet, the artist's brother, stands in the center with his hands behind his back, and to his right sits the composer Offenbach. All these people—"sparkling boulevard society," as Moreau-Nélaton called them—were habitués of Tortoni's or the Café Guerbois, the two places Manet frequented.

This remarkable work leads us on from wonder to wonder. There is always something new to be discovered. I cannot understand Huysmans, who jotted down the following note on this canvas in a catalogue I have seen, "Detestable! Merely commonplace. In any case Manet never could paint crowds; he arranges them stiffly according to rule. His patches of color jostle one another; they have no balance."

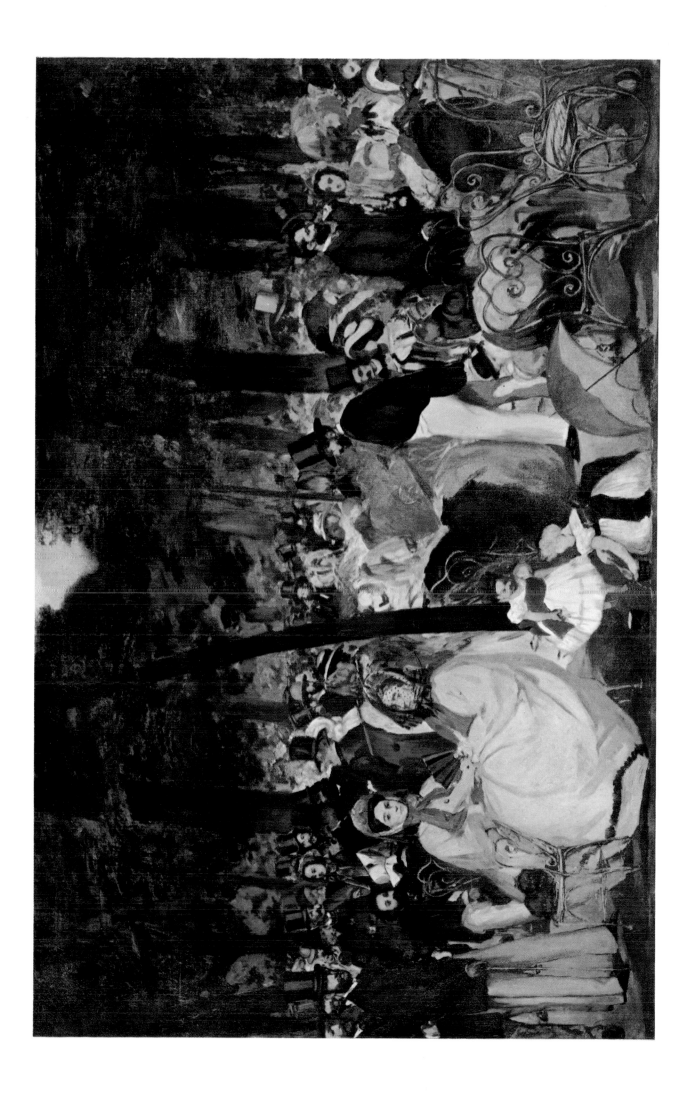

Painted 1860
58 x 45 in.
Courtesy of The Metropolitan Museum of Art, New York
(Gift of William Church Osborn, 1949)

The Guitarist

This is a polished work in which Manet has been careful not to depart too far from convention. He has applied the paint thickly, and in passages like the guitar or the still-life study of onions and jug, with a sheer material satisfaction reminiscent of Courbet. But we can already see the mature Manet in the characteristic colors, in the sulphur-green of the bench and the warm gray of the singer's trousers. He has cheated a little with the position of the right foot, which should be resting naturally on some object. True, no critic seems ever to have noticed this. The left-handed guitarist is playing a guitar apparently designed to be played with the right hand, but this too is a minor consideration.

"I think I have it right, don't you?" said Manet to his friend Antonin Proust, who visited the studio while the painting was still on the easel. "What do you think of it? The head, you know, I painted all in one go. After two hours' work I looked in my little black glass and it was just right. I didn't touch it again."

When it was exhibited at the Salon of 1861, the painting was christened the **Guitarero** by Théophile Gautier, who hailed it enthusiastically in *Le Moniteur Universel* of July 3: "Caramba! Here is a Guitarero who does not come from the Opéra-Comique and who would not look well in a romantic engraving. But Velázquez would give him a friendly wink, and Goya would ask him for a light for his papelito.... There is a great deal of talent in the life-size figure, with its paint thick from the tube, its bold brushwork, and realistic colors." Hector de Callias in *L'Artiste* was no less enthusiastic: "What poetry in this muleteer, bare wall, onion, and cigarette butt; their different smells pervade the whole room." The painting was nevertheless severely criticized. It was far too realistic for the traditional school.

The Reves collection contains an admirable watercolor of the same subject.

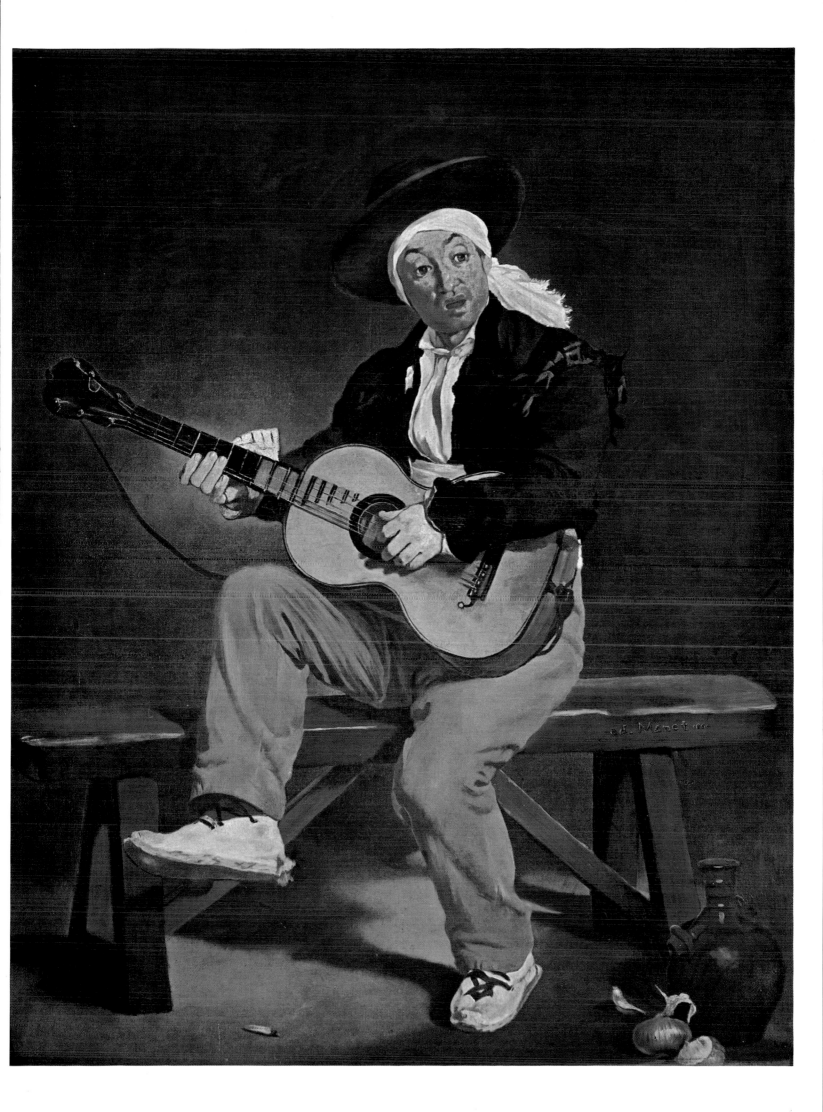

Painted 1862
24 x 36 in.
The Phillips Collection, Washington, D.C.

Le Ballet Espagnol

I know of no painting fresher, more dynamic, more modern in the Baudelairian sense of the word than this one, with its frenzied rhythm. Technically speaking, it shows Manet at the height of his virtuosity. I think that if I had to choose among all his works the one which gives the best idea of his talent, flawless and uninhibited, without dull passages, without the slightest weakening of interest, I would choose this one, to which my eyes constantly returned at the Manet exhibition at the Orangerie in the Tuileries in 1932.

With astonishing freedom, unsurpassed depth of feeling, and an unusually happy choice of colors, Manet has painted the Spanish company who were dancing at that time at the Hippodrome in Paris. Among them are Lola de Valence, seated, and, standing, the famous dancer Mariano Camprubi.

For this painting Manet made a preliminary drawing heightened with watercolor and gouache. After painting the company, he asked Lola de Valence to pose for him several times. Jacques de Bietz described Manet at this time: "This rebellious spirit, who deliberately defied all conventions and despised all the tricks that win prestige in the artificial world of high society, was no brute, no coarse stable-boy, no ruffian. Far from it. It was impossible to deny that this new artistic genius, from whose alleged noxious and sordid realism society was turning in disgust, was, as all who had met him could testify, a perfect gentleman, well-bred and distinguished, amiable and courteous, and, what is more, most elegantly dressed."

Manet exhibited this work for the first time at the Galerie Martinet, boulevard des Italiens, in February and March 1863, together with **Music in the Tuileries**, **Lola de Valence** (pages 51 and 57), **Street Singer**, and **Old Musician** (figures 5 and 7).

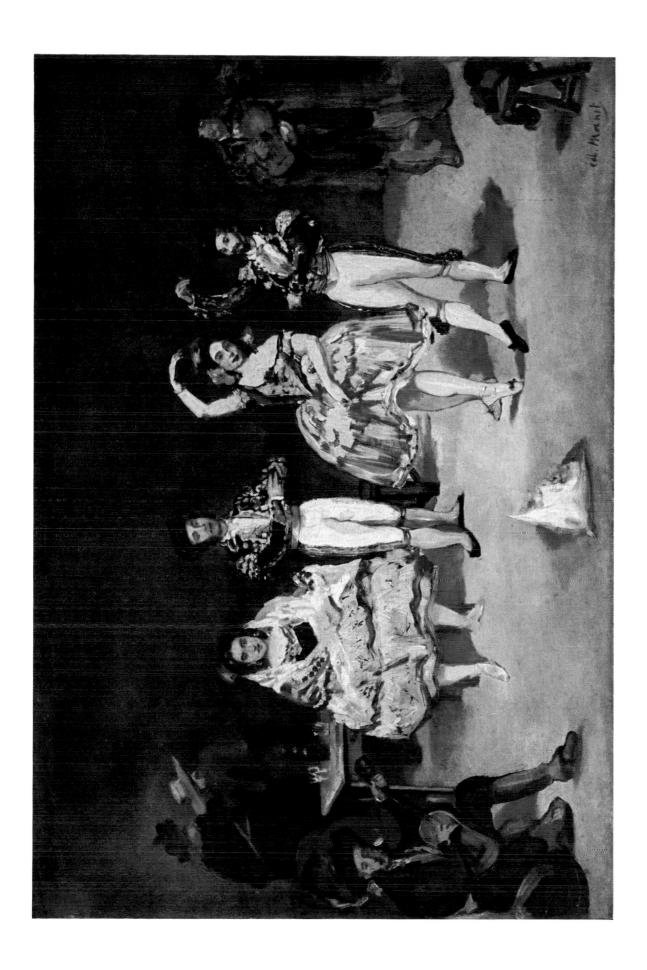

Painted 1861–62
48 3/8 x 36 1/4 in.
Museum of Impressionism, The Louvre, Paris

Lola De Valence

This portrait of the Spanish ballerina is one of Manet's finest and most exciting works. The audience, glimpsed on the right, throbs miraculously with life. The artist reveals himself to be confident, incisive, both brilliant and substantial—in my opinion, faultless. He was never to surpass this color, which appears here in its full force. As for the Spanish influences which inspired this picture, there is little evidence of them aside from some faint reminiscences of Goya. With Lola, modern art had scored an outstanding success.

Baudelaire, rarely voluble in Manet's praise (in fact, he mentioned his friend only in relation to the exhibition of etchings in 1862), wrote a quatrain describing Lola's inescapable charm, comparing her to a pink and black jewel:

> *Entre tant de beautés que partout on pent voir,*
> *Je comprends bien, amis, que le désir balance;*
> *Mais on voit scintiller en Lola de Valence*
> *Le charme inattendu d'un bijou rose et noir.*

These lines had as a subtitle, "Inscription for the painting by Edouard Manet." Before appearing in *Les Epaves* in 1866, the verses were first published beneath the etching of the picture issued by the Society of Etchers in 1863.

In *Le Gaulois* of July 4, 1872, Barbey d'Aurevilly said that **Lola de Valence** was too Chinese for him and he not Chinese enough for it. "But what I like better than any picture, what appeals to me right from the start, is the artist as a man, determined to trample underfoot everything commonplace and to force the recognition of initiative at the point of the sword." Speaking of the much-criticized portrait of the prima ballerina of the Spanish company then in Paris, Edmond Bazire said that the picture "committed the considerable error of being a sincere reproduction, a real and striking portrait of a finely built woman." Manet must certainly have flattered his subject a little. This is immediately apparent when one compares the tall figure here with the heavy figure shown in **Le Ballet Espagnol** (page 55).

The folios in the Drawing Collection at the Louvre contain a watercolor of Lola (figure 13), one of the most dazzling and finished of Manet's works in this medium. Manet used this study for his etching of Lola and for the lithograph on the cover of Zacharie Astruc's serenade, **Lola de Valence**.

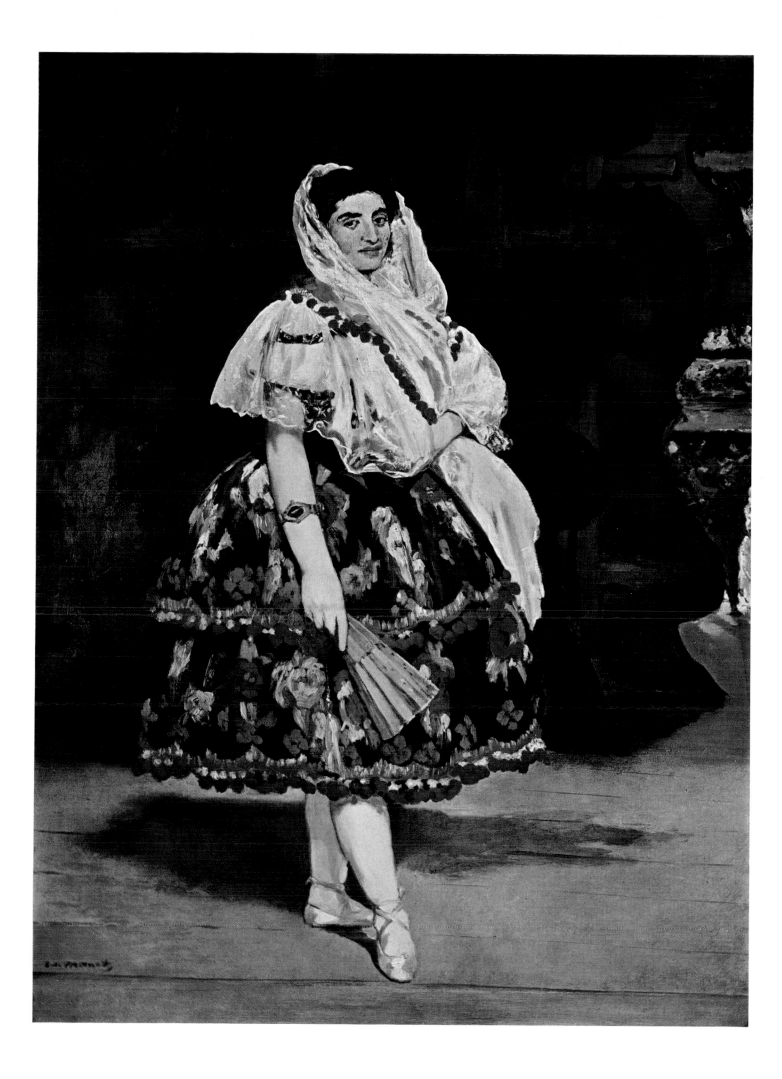

Painted 1862
17 x 17 in.
Museum of Fine Arts, Boston

Portrait of Victorine Meurend

It is easy to imagine the reactions of those who expected pictures to be finely finished when we look at this candid portrait, boldly painted in a sweeping and simplified style. This is the first work in which Manet displays his strong and rapid touch and also his first portrait of the model who was to pose for him regularly until 1875—for **Luncheon on the Grass**, **Olympia**, and **Gare Saint-Lazare** (pages 61, 63, and 93).

In 1862 Victorine Louise Meurend was only twenty years old, but she already had a certain gravity of expression. Tabarant writes that she had "fine eyes, animated by a fresh and smiling mouth. With that, the lithe body of a Parisian, delicate in every detail, remarkable for the flowing line of the hips and the supple grace of the bust." Where did she come from? Théodore Duret claims that Manet met her at the Palais de Justice, where he "had been struck by her unusual appearance." She lived in the rue Maître-Albert in the fifth arrondissement, where the painter had the proofs of his first etchings printed. She played the guitar and sketched.

In this portrait, Manet shows her thoughtful, if a trifle limited. She has the red-gold hair of a Venetian that reappears in **Luncheon on the Grass** and **Olympia**, where the breadth of the face is accentuated even more. She wears about her neck the black ribbon that Manet often placed on his models. The black accents on the collar are still a little awkward and heavy in this experimental study; very shortly Manet was to learn to handle his shadows with great mastery.

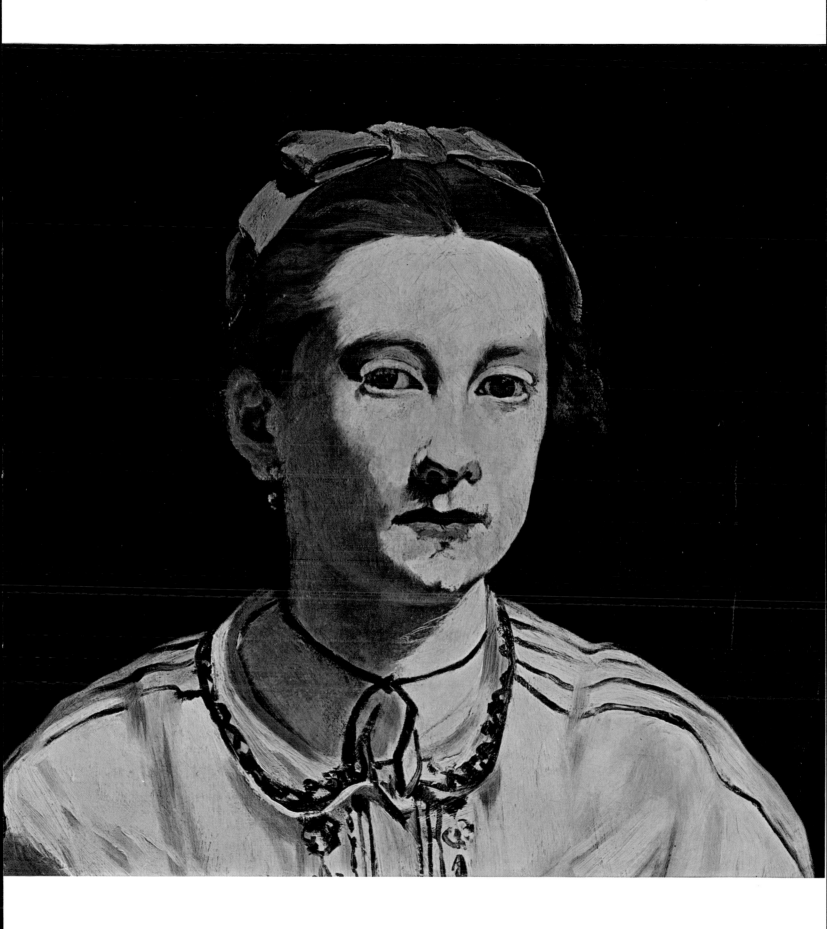

Painted 1863
83 1/8 x 106 1/4 in.
Museum of Impressionism, The Louvre, Paris

Luncheon on the Grass

Luncheon on the Grass, originally called **The Bath**, is one of those artistic manifestos that provoke endless comment, both written and spoken. On the whole, however, despite its distinguished antecedents (Marcantonio Raimondi's engraving of Raphael's **Judgment of Paris**, and Giorgione's **Pastoral Concert**: figures 10, 11), it is not one of Manet's best compositions. The men, for example, seem a little stiff, and the hand of the man at the right holding a cane is somewhat clumsily painted. The passages which show the artist at his best are the nude and the still life, so freshly painted and admirably situated in the landscape, and the poetic vision of the girl bathing in the middle distance that rounds off the composition. The success of the painting lies in the harmony between figures and landscape. This theme, a favorite study for Watteau and Fragonard, had been abandoned by David, Gericault, and even Delacroix. Corot's nymphs were mere accessories to his landscapes. Only Courbet, most notably in **The Rest during Haymaking**, had attempted to master the problems of this subject.

Antonin Proust records in his memoirs Manet's comments on the inception of this work. He recalls one Sunday at Argenteuil, near Gennevilliers, where the Manet family owned a few houses and property of about one hundred and fifty acres. He and Manet were stretched out on the river bank, "watching the white skiffs furrowing the Seine and making white patches against the dark blue of the water. 'It appears that I have to paint a nude,'" said Manet to his friend. "'Well, I will paint one in the transparency of the air, with people like those you see down there. The public will tear me to pieces, but they can say what they like!' Whereupon he brushed his top hat, put it on, and got up to go."

That was August 1862. Manet had already made some progress with his studies for the picture. For the figure of the girl bathing, he first had a model pose for him, and afterward used Victorine Meurend. Ferdinand Leenhoff, later his brother-in-law, was the model for the man in the center.

When it was hung in the Salon des Refusés, **Luncheon on the Grass** was greeted with a burst of indignation. It gave Manet the notoriety from which he was to suffer for so long. What most aroused the anger of artists, critics, and public alike was not, says Gabriel Séailles, "either the subject or its realism, but the new technique, which ran counter to all preconceived ideas of art and all the theories of the schools." In *Le Figaro* of May 24, Charles Monselet, signing himself "M. de Cupidon," wrote as follows: "M. Manet is a disciple of Goya and Baudelaire. He has already succeeded in disgusting the bourgeois." The traditionalists were startled to see a nude woman (recognizable as a model rather than a nymph) seated with two fully clad art students. Manet's name was on the lips of everyone in Paris, from the ateliers to the most proper drawing rooms.

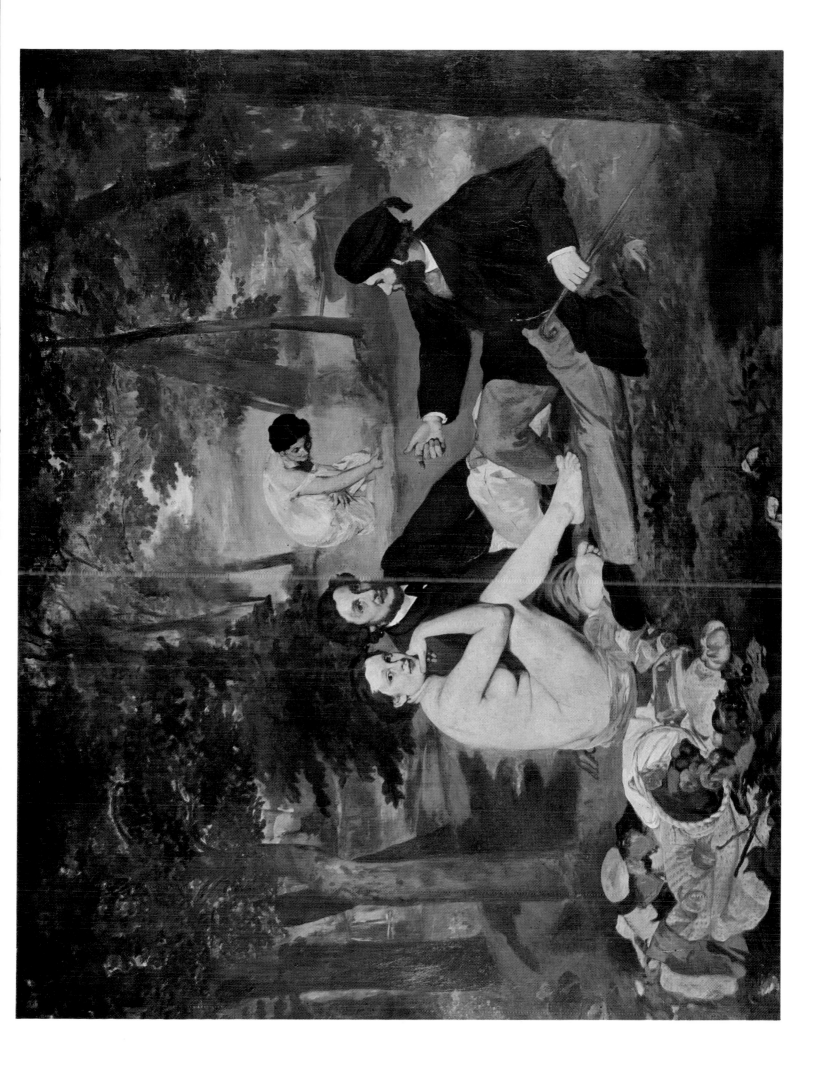

Painted 1863
51 x 73 3/4 in.
Museum of Impressionism, The Louvre, Paris

Olympia

At one time, when reproductions of paintings were rare, people made long, detailed descriptions of them. The following is one such description, copied out by Léon Koëlla-Leenhoff:

> A girl is lying on a bed over which a cover of some oriental material has been thrown. The pillows on which she is leaning raise the bust slightly, and the head, turned to the right, is seen full-faced. Her only ornaments are a red flower in her hair, a narrow black ribbon round her neck, and a sandal on one foot. In the shadow of the background, a negress is presenting her with a sheaf of bright-colored flowers wrapped in paper. At the foot of the bed a black cat is arching its back.

The strange thing was that this picture was accepted for the 1865 Salon, where it took two guards to protect it from the walking sticks of the indignant visitors. The work caused an uproar—it shocked by its luminosity. It is one of the finest symphonies in white in the whole of art. It seems so fresh that it might have been painted only yesterday. We are amazed to discover cracks in the paint.

The contemporary press was unsparing. In *Le Temps* of January 16 Paul Mantz said that "this wretched little woman displays her unattractive form enclosed in stiff outlines that look as though they were traced with soot." Edmond Bazire tells us that "sticks and umbrellas were brandished in the face of this awakening beauty. Crowds formed which the army could not disperse. The authorities were so alarmed that they set two attendants in gold braid to mount guard over her. But even that was not enough! When as usual the exhibition was rearranged, they placed her offending nakedness so high that neither demonstrations of anger nor the eye could reach her."

Manet, discouraged, wrote to Baudelaire, "I am being subjected to a hail of insults." From Brussels the poet answered, "Do you think you are the first to whom such a thing has happened? Are you a greater genius than Chateaubriand or Wagner? People ridiculed them just as much, but they didn't die of it."

"So now you are as famous as Garibaldi," Degas shrewdly observed to Manet when the uproar had died down.

One day, however, **Olympia** was to go to the Louvre. At Clemenceau's insistence, the painting was transferred to the Louvre from the Luxembourg collection by decision of M. Dujardin-Beaumetz, Under Secretary of State for Fine Arts. According to the *Daily Telegraph* of February 7, 1907, this event caused "a mild sensation."

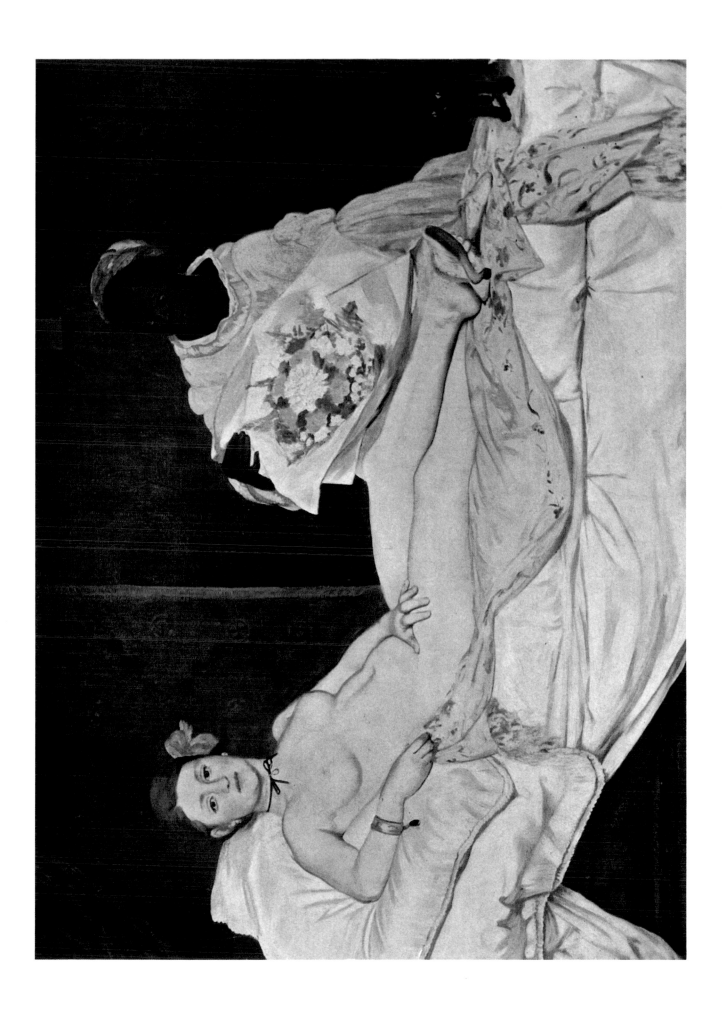

Painted 1864
29 3/4 x 60 1/2 in.
National Gallery of Art, Washington, D.C.
(Widener Collection)

The Dead Toreador

This picture originally formed part of a much larger one, **Incident in the Bull Ring**, which was exhibited at the 1864 Salon. Manet, dissatisfied with it, cut it in two. One half, **Bullfight**, is in the Frick Collection in New York, and the other is this **Dead Toreador**, which was the lower part of the original work. (Manet is known to have cut up several of his pictures in this way.)

"A wooden torero killed by a rat," was Edmond About's comment on the painting hung in the Salon, for the bull was generally thought to be ridiculously small. Théophile Thoré, in *L'Indépendance Belge* of June 26, said of a letter he received from Baudelaire, "it is not possible that Manet should never have had a second view of Goya and El Greco, through some intermediary." Thoré was persuaded that the **Dead Torero** was directly inspired by Velázquez' painting of a dead man which was at that time in the Galerie Pourtalès, in Paris.

This is one of Manet's most sensitive and delicate works. Although the body is perhaps a little wooden, or at any rate exaggeratedly stiff, the color harmonies reveal Manet as a master colorist. What words can describe the old-rose of the muleta, the silvery, silken texture of the white stockings and sash, and the deep, resonant blacks against the dark olive background?

The painting was hung at the Galerie Martinet in the boulevard des Capucines. Durand-Ruel bought it at Manet's studio in 1872 for 2000 francs and sold it to Faure, the baritone, for 3000. He then bought it back from Faure to sell it to Mr. Joseph Widener in the United States. In collaboration with Félix Bracquemond, Manet made an etching of the painting in 1874.

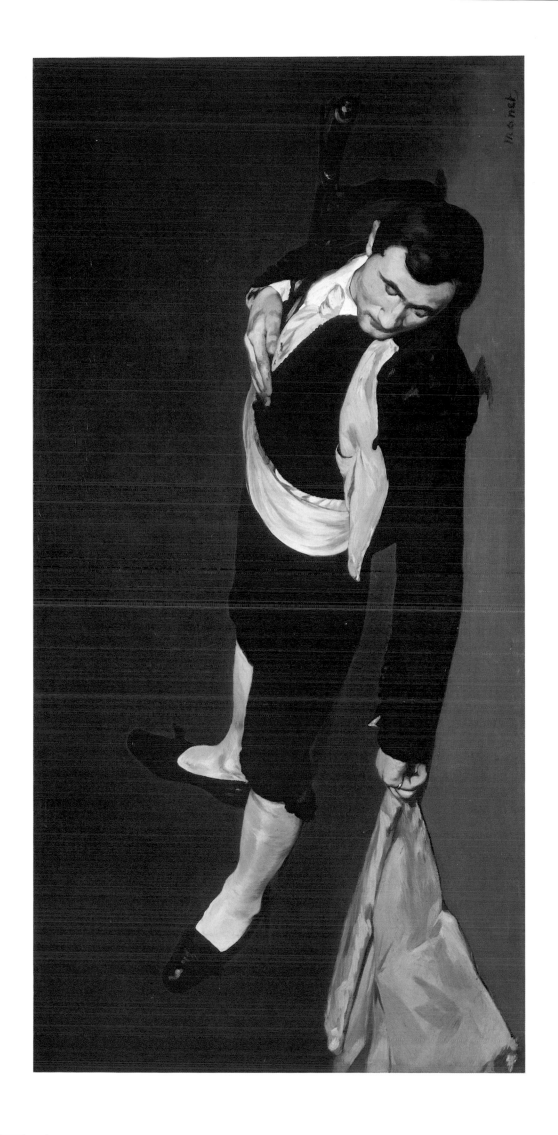

Painted 1864
54 5/8 x 51 1/8 in.
Johnson Collection, Philadelphia

Alabama and Kearsarge

This seascape enlivened by a naval engagement is one of the few works Manet painted entirely in blues and greens—a most difficult combination of colors. It is also one of the works that received the highest praise during his lifetime. The sea is excellently rendered by one who knows it well. Manet has taken one of Turner's favorite themes and treated it in a realistic manner. There is nothing to show that Monet, Pissarro, and all the Impressionists would return later to the shuddering impacts, the clouds of smoke, and the mysterious and fearful suggestions of marine paintings by the great English Romantic. For Manet and the people of his day, this naval battle was a calm and even restful spectacle. As I see it, the real struggle in this scene of combat is between the sea and the sky, between the waves, the smoke, and the clouds—the true pictorial elements of the canvas.

The painting records an incident in the Civil War, when on June 19, 1864, off Cherbourg, the Kearsarge, a corvette belonging to the United States Navy, attacked and sank the Alabama, a Southern privateer. The engagement was expected, and the Cherbourg hotels, already full to overflowing with American sailors, were turning away crowds that had flocked to see the sight. According to Tabarant, Manet was an eyewitness of the battle.

This seascape was praised by Duranty in *Paris-Journal* and by Camille Pelletan in *Le Rappel*. But the greatest eulogy it received was from Jules Barbey d'Aurevilly in *Le Gaulois* on July 4. "I come from the sea," he wrote. "I was brought up with its spray in my nostrils. I have corsairs and fishermen among my ancestors... and this sea of M. Manet's carries me off on the crest of its wave. It is a miracle of observation and execution.... M. Manet might have painted the sea alone. He could have left out his ships and his picture would have been greater still. Just the sea, with its mounting green swell, mightier than the human beings scurrying about and firing at one another across its surface.... How great that would be—as an idea and as a picture!"

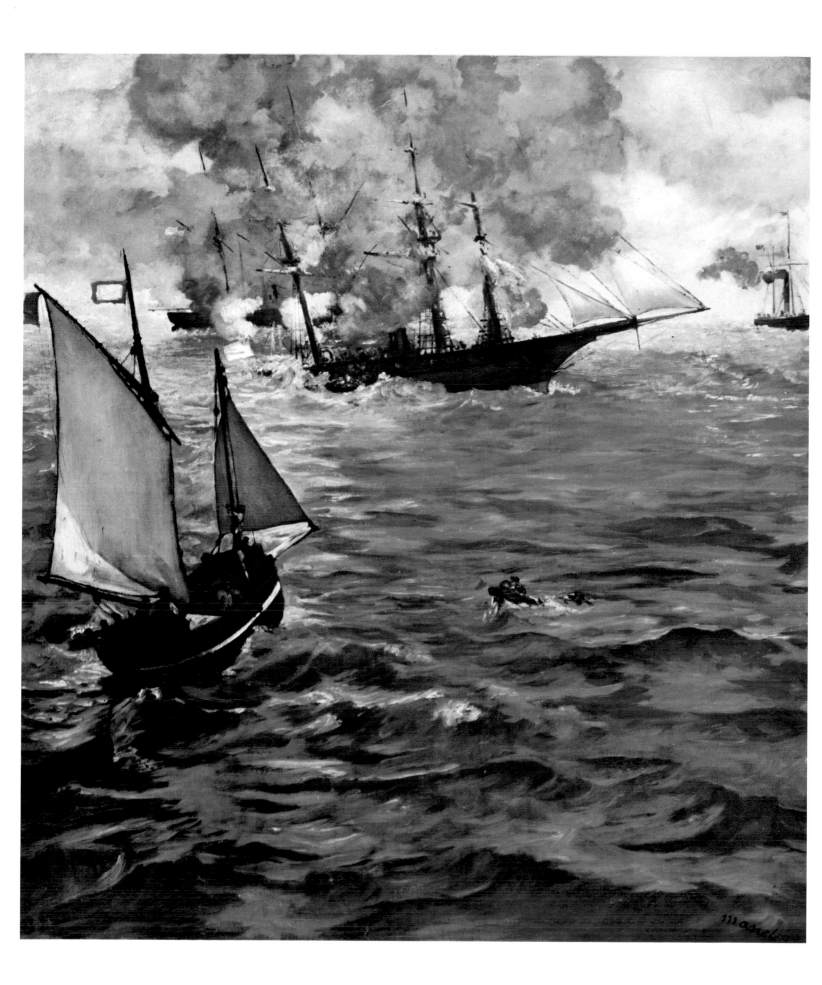

Painted 1864
28 7/8 x 36 1/4 in.
The Art Institute of Chicago
(Mr. and Mrs. Lewis L. Coburn Memorial Collection)

Still Life with Carp

After the sea, its creatures. This still life, in which you can smell an odor of brine and seaweed, is one of Manet's finest. It is painted with a bold, masterful touch. The artist has rendered perfectly the belly and silver scales of the fish with its reddish head, and it is quite recognizably a mullet and not a carp. Beside it, the red gurnet gives a touch of brighter red. The oysters add a note of freshness, and the lemon, Manet's favorite fruit, stands out with a burst of brilliance against his grays and blacks.

The whole composition is seen against a somber background of bluish tints. The cloth recalls the cold tones of **Olympia** (page 63).

Of the execution of this still life, exhibited with others at the Martinet and Cadart galleries, Théophile Thoré wrote in *Le Constitutionnel* of May 16, 1865, "Certain works by M. Manet, such as the still-life compositions in which he scatters fruit and fish on a dazzling white cloth, are of a high pictorial quality."

Pleased with this comment from a critic who was a connoisseur of painting and who, under the name of Burger, had just discovered Vermeer, Manet presented Thoré with one of his flower studies.

There is another fine still life of the same period, showing the red mullet on a white cloth with an eel lying across it.

In this work, Manet is still following the old school of still-life painting. He treats each object separately, making it emerge from a dark background into the light, whereas the Impressionists were soon to blend their objects into the surrounding daylight.

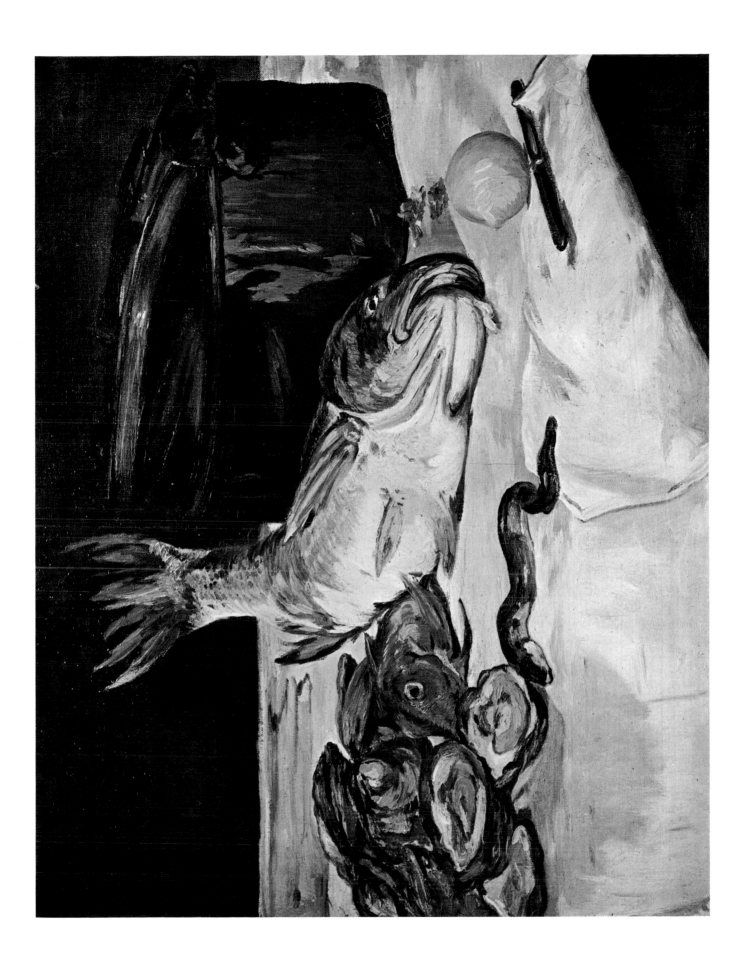

Painted 1866
63 x 38 1/8 in.
Museum of Impressionism, The Louvre, Paris

The Fifer

In this work, Manet has for the first time flooded the entire canvas with light. The boy, facing us squarely and bathed in brilliance, stands against a flat, luminous background. The bold treatment of the subject is one of those master strokes that can be risked only by innovators fired by the joy of discovery. In this gay picture, which resembles a colored bas-relief, Manet establishes himself as a disciple of Fouquet.

And yet, at the sight of **The Fifer**, the critics exclaimed that Manet's painting was flat, as flat as the color woodcuts from Epinal, as they said then. The monumental simplicity which delights us today shocked the adherents of the traditional school. Manet had been criticized for his "sooty" shadows, particularly in **Olympia** (page 63) and **Dead Christ with Angels**. In this picture he sought to take his revenge by modeling with light and using shadows only in the hands. As for the color, Manet has laid it on in large patches, a little after the style of Raphael's portraits. But this too went unnoticed.

The model was a boy from the *Garde Impériale*, a young soldier brought to Manet's studio by a Major Lejosne, an officer who often entertained writers and artists, including Baudelaire, in his apartment in the avenue Trudaine. This picture and the **Tragic Actor** were rejected by the jury of the 1866 Salon.

We may recall here what Baudelaire said of the public (and the official jury) in their relation to the artist, "They will never be anything but a clock that runs slow." Zola, after "extending a hand of friendship to this painter who had been banned from the Salon by a group of fellow artists," wrote in *L'Evénement* on May 7, "Of all Manet's works the one I prefer is certainly The Fifer, a work which this year was refused." After describing the subject, the novelist, who had as yet published nothing but the *Contes à Ninon*, added: "I do not think it is possible to achieve a more forceful effect with such uncomplicated means. M. Manet is by temperament incisive, and he can be trenchant. He fixes his subjects forcefully, with no fear of Nature's asperities; he does not hesitate to proceed from white to black, and he gives their full vigor to the different objects, which stand out clearly from one another. Quite naturally he tends to see things in simple, vigorous patches. Indeed, it may be said of him that he is content to find the right colors, then to juxtapose them on the canvas." The following year, in *La Revue du XIXe siècle*, Zola resumed his offensive: "One of our great contemporary landscape artists has said that The Fifer looks like 'a costume-dealer's signboard,' and I agree with him if what he means is that the young musician's uniform has been handled with the simplicity of a fashion sketch."

But Manet's detractors did not relent. "A knave of diamonds pasted on a door" was what they said of **The Fifer**.

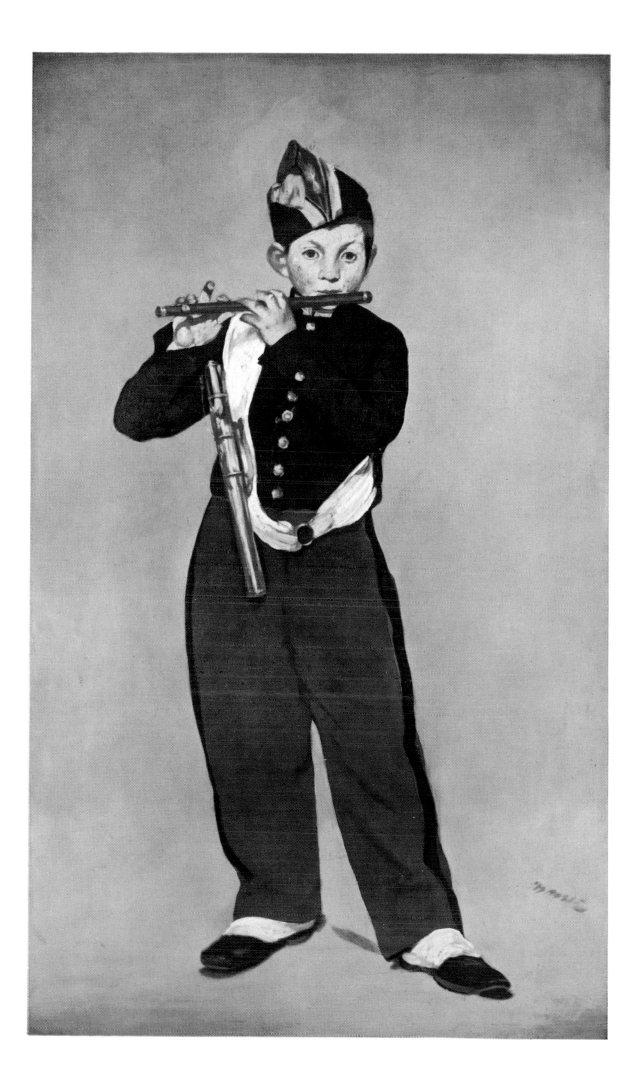

Painted 1866
18 7/8 x 23 7/8 in.
The Art Institute of Chicago
(Mr. and Mrs. Martin A. Ryerson Collection)

Bullfight

This is the most arresting and realistic of Manet's bullfights and also the most vibrant in technique. The arena radiates sunlight, and the bull and the toreros' hats make black splashes against its brilliance. A few bold strokes sketch in the crowd in the boxes and on the tiers of seats. We marvel at the skill with which the artist has preserved the unity of his composition without detracting from its effect of uncalculated immediacy. The encounter of man and beast is admirably defined and centered. The red madder of the *muleta*, the blood from the ripped belly of the horse, the purples, mauves, and vermilions of the spectators, all build up the pictorial atmosphere of this bull ring, with long shadows stretching out across the arena.

In this painting, although inspired by a Spanish scene often treated by Goya, Manet is entirely himself. The picture is one of those which reveal him as a forerunner of Impressionism, and he has succeeded here, more than in many other works, in conveying a feeling of drama and bringing out the cruelty of the fight. Death can be sensed beneath this clear blue sky.

Among the bullfighting scenes painted by Manet, this one, and the one in the possession of the Baronne de Goldschmidt-Rothschild, are certainly the best. Although the Chicago painting is the less finished of the two, it seems to me to have more pictorial character, with its black bull ready to charge and the suggestion of the seated crowd.

We know from Tabarant that this painting was bought by Durand-Ruel in January 1872 for 500 francs and sold for 5000 francs in 1886 to Mr. Inglis of New York. It was bought back from him by Durand-Ruel and resold to the Art Institute of Chicago for 70,000 francs.

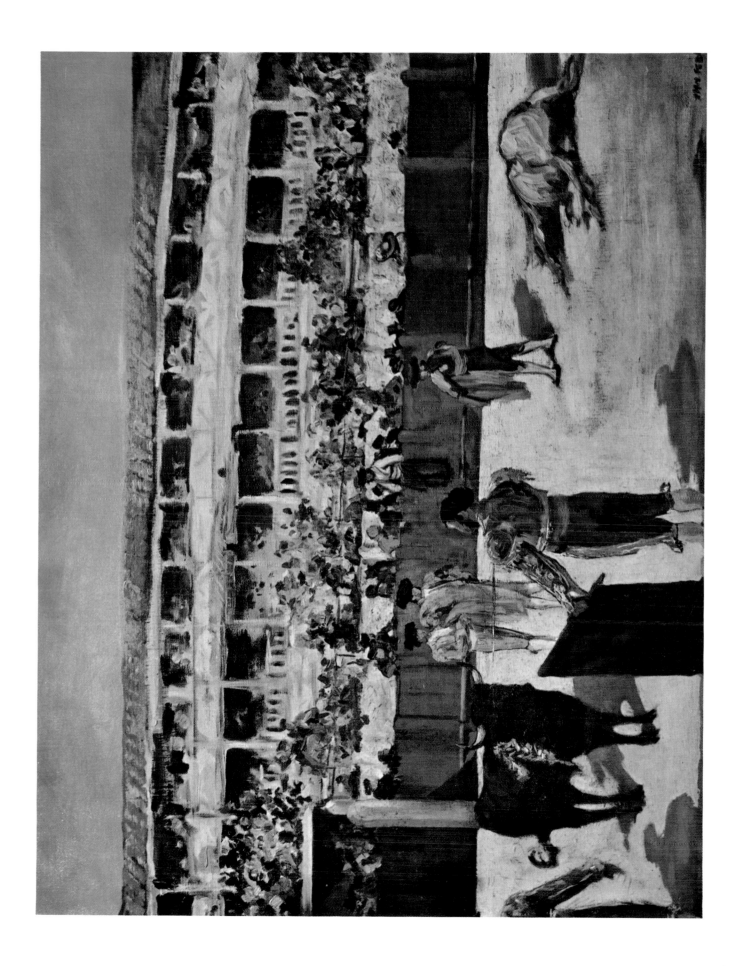

Painted 1867
99 1/4 x 120 1/8 in.
Städtische Kunsthalle, Mannheim

The Execution of Emperor Maximilian

With the bullfighting scene that precedes it, the **Execution of Emperor Maximilian** is one of the few works in which Manet seeks a dramatic effect. The painting illustrates the climax of a well-known historical episode. Napoleon III intervened in Mexico to prevent it from gravitating toward the United States, for which he had no sympathy and which was at that time too involved in the Civil War to protest his actions effectively. French troops invaded Mexico in June 1863, and an assembly of Mexican notables proclaimed Maximilian— the brother of Franz Joseph of Austria—Emperor. But, once the Civil War was over, the United States demanded that the French withdraw their army, and Napoleon, in 1866, complied. Deserted by his supporters, Maximilian was captured in 1867 at Querétaro, condemned to death, and shot in reprisal for the summary executions he himself had ordered.

This is certainly the work which shows most clearly the influence of Goya (note, for example, the rapid treatment of the people looking over the wall) and, in particular, the influence of the painting in the Prado entitled **The Third of May**, 1808 (figure 29). But there is one thing that is quite wrong according to the old school. The spectators could not be in the position in which they are shown, in view of the height of the wall, unless they were standing on scaffolding. Conscious no doubt of this faulty drawing, the artist, perhaps to disguise it, has made the foreground stand out sharply from the background and diverted attention from the base of the wall by showing it as little as possible between the black-trousered legs of the prisoners and the soldiers. "You can see right away that they are French," Meier-Graefe said of the soldiers. As a matter of fact, for want of Mexicans, Manet had been forced to borrow a squad from a French regiment.

In Manet's painting the soldiers have just fired (the chests of Maximilian and his two favorites are enveloped in smoke). In the back, an officer is preparing to give the *coup de grâce*.

This picture, taken to the United States by the singer Emilie Ambre, a friend of Manet, was exhibited in New York in December 1879, and in Boston in January 1880.

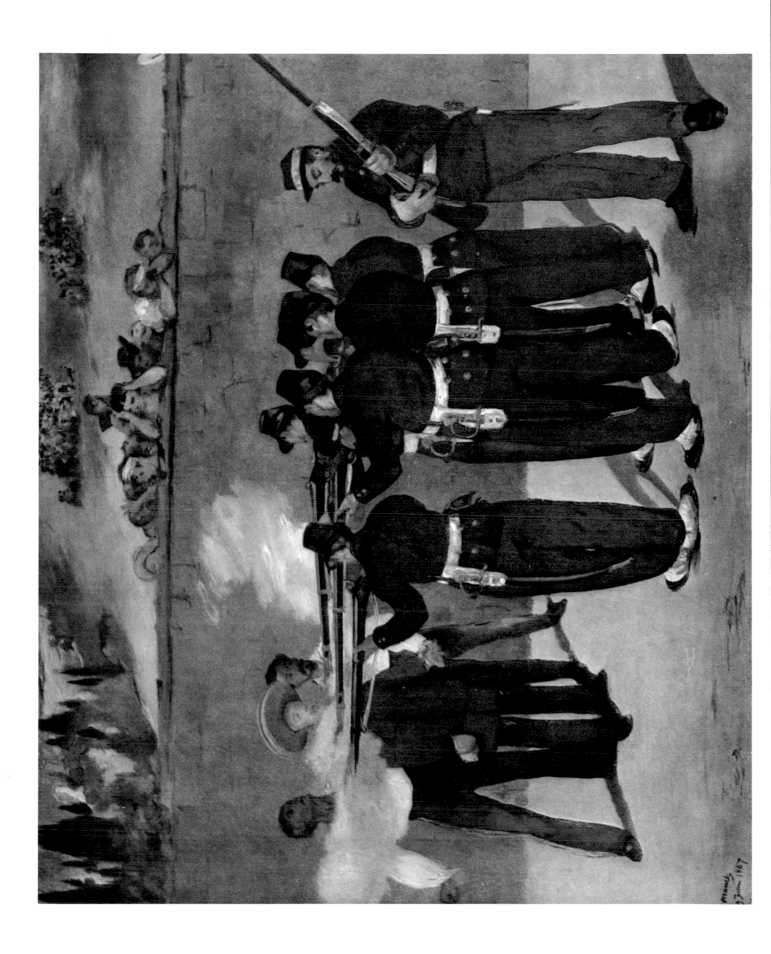

Painted 1868
57 1/8 x 44 7/8 in.
Museum of Impressionism, The Louvre, Paris

Portrait of Emile Zola

On January 1, 1867, Zola published in *La Revue du XIXe siècle* a second important article on Manet. "What a splendid New Year's present," wrote Manet, thanking him. The following year he expressed his gratitude to the writer by painting this portrait and presenting it to him. Zola posed for the painting in Manet's studio in the rue Guyot, but he is shown working at his desk in his own surroundings. Manet has pinned up on the wall a reproduction of **Olympia** and a Japanese print; there is also a Japanese screen. The picture radiates an astonishing freshness, and, as with Degas's portrait of Duranty or Cézanne's of Gustave Geffroy, one feels that the artist is in sympathy with his subject.

In the 1868 Salon, Zola's portrait was badly hung, high up in a corner near the doors. It was ill received by the press. In *Le National* Henri Fouquier deplored the fact that Manet had followers, and wrote pedantically, "This year Manet has painted Zola, the high priest of the coterie of present-day 'nature-haters.' The accessories are not in perspective, and the trousers are not made of cloth." Luc-Olivier Merson, a fashionable artist of the period, made a comment worthy of a total ignoramus in *L'Année illustrée* of May 26, "The trouble is that the man can neither draw nor paint."

Of his experience as a sitter, Zola wrote in *L'Evénement illustré*, May 10, 1868

I remember posing for hours on end. With limbs numb from remaining motionless and my eyes weary from staring at the light, the same thoughts kept murmuring in the back of my mind. The foolish chatter one hears every where, the lies of some and the platitudes of others, all that human noise that flows idly by like dirty water, was far away. It seemed to me that I had left the earth for a higher sphere of truth, and I was filled with pity and disdain for the poor wretches stumbling along down below.

Now and again, half-dozing off as I sat there, I looked at the artist standing at his easel, his features taut, his eyes bright, absorbed in his work. He had forgotten me; he no longer realized that I was there.

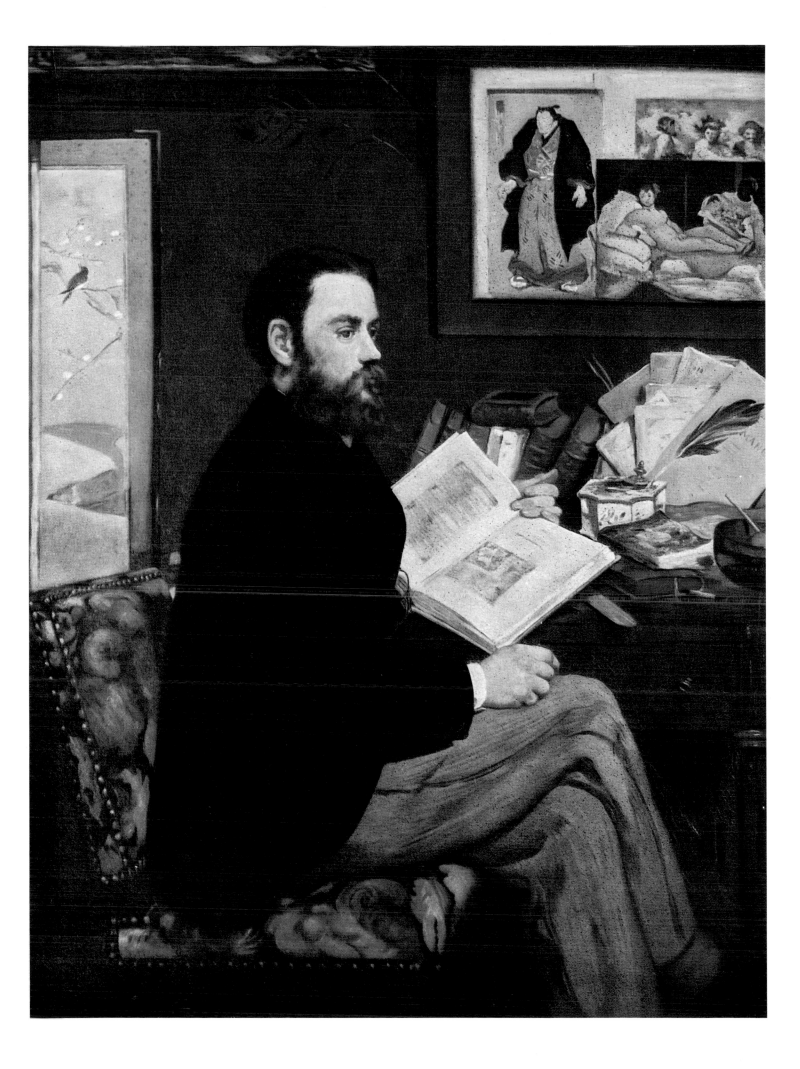

Painted 1868
18 1/8 x 13 3/4 in.
Petit Palais, Paris

Portrait of Théodore Duret

This is one of Manet's most successful and natural portraits. The informal composition against a plain background, the stool that holds a black tray with a carafe, glass, and lemon, the walking stick that seems to be scratching Manet's signature with its point, the bold style, the little symphony in black relieved only by bright cadmium yellow—all make this a little masterpiece.

Manet, who had gone to Spain to escape the jibes and malice of the critics after the failure of **Olympia** (page 63), first met Duret in Madrid. They visited the cafes of the Calle de Sevilla together. "It became our favorite haunt," wrote Duret. "We went to bullfights and Manet made sketches to use later for his paintings. We also went to Toledo to see the cathedral and the El Grecos."

In 1868 Duret founded *La Tribune* with Eugène Pelletan and Glais-Bizoin. Manet would sometimes call in at the editor's office to relax from his labors. Duret, who the year before had written a book entitled *Les Peintres français en 1867*, in which he praised Courbet and Manet's early works, came to pose for the artist in his studio in the rue Guyot. "The picture," Duret tells us, "was all in gray tones. But when he had finished it—and I, at least, felt that it was successful—I saw that Manet was not satisfied. He kept wanting to add something. One day I came back and he placed me again in the same pose, with a stool beside me upholstered in deep red, which he began to paint. Then it occurred to him to lay a book under the stool and paint its light-green paper cover. He next set on the stool a lacquered tray with a carafe, a glass, and a knife. All these objects added their different shades of color in a corner of the picture in a way that Manet had not foreseen at the outset and which I would never have imagined. Finally, he added one more unexpected object— a lemon resting on top of the glass on the little tray.

"With some surprise I watched him add these things one after the other, when, wondering what he was up to, I suddenly understood that I was witnessing Manet's instinctive and organic way of seeing and feeling."

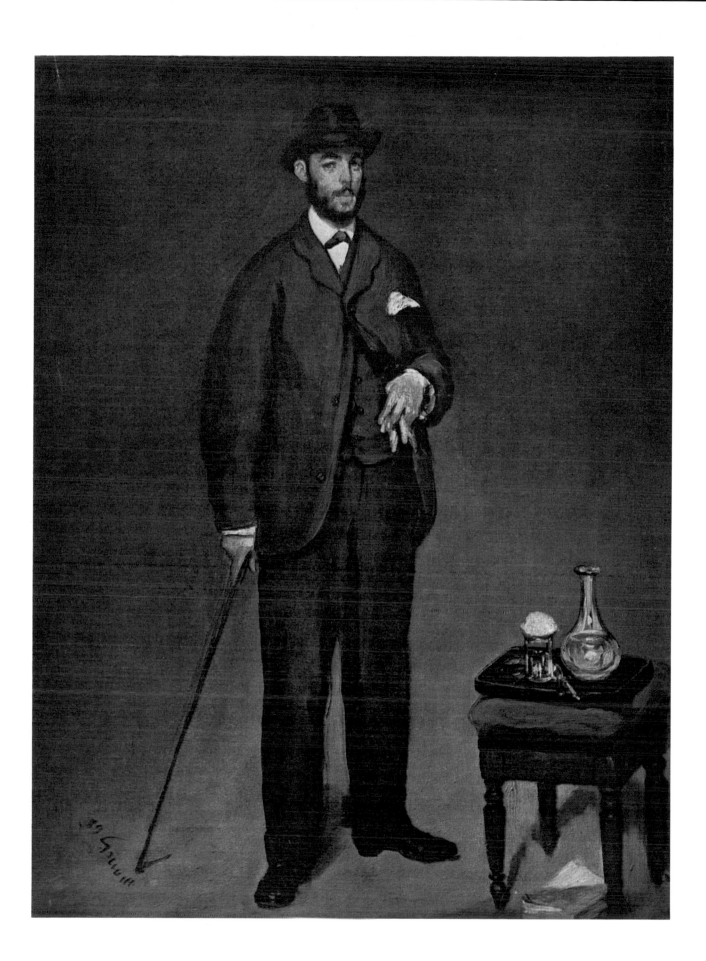

Painted 1868
47 1/4 x 60 5/8 in.
Bavarian State Painting Collections, Munich

Luncheon in the Studio

Here all is in harmony: the carefully distributed light, the delicate contrasts of yellows and blacks, the blue tints of the cloth, the muted background. Everything has that unique balance that constitutes the charm of a Vermeer: the instant is truly fixed for all time. The armor and the saber on the left, which have been so much criticized, are put there as a contrast to round off the composition with skillful curves. **The Balcony** (page 83), painted in the same year, is darker and more strongly accentuated.

For the cat alone in this picture, Manet made no less than sixteen studies, which are to be found in the Drawing Collection at the Louvre, in the third album of the Auguste Pellerin collection.

This magnificent work was in fact painted in one of the rooms in the apartment in Boulogne from which Manet watched the ships in harbor. It was sold on November 8 to the baritone Faure, along with **Le Bon Bock** (figure 42) and the Masked Ball at the Opera. The model for the young man in the straw hat was Léon Koëlla-Leenhoff. This figure drew a sneering comment from Théophile Gautier—that "perfect magician of French literature" as Baudelaire called him— who was often a very poor critic when it came to his contemporaries. He had doubts about the **Luncheon**. "The foppish figure leaning against the table," he wrote in *L'Illustration* of May 15, "is very true to type, both in pose and dress. The servant and the bearded man (this is a portrait of the painter Auguste Rousselin, whom Manet had met at Couture's home) are quite sensitively done, but why the weapons on the table? Is it a luncheon before or after a duel?"

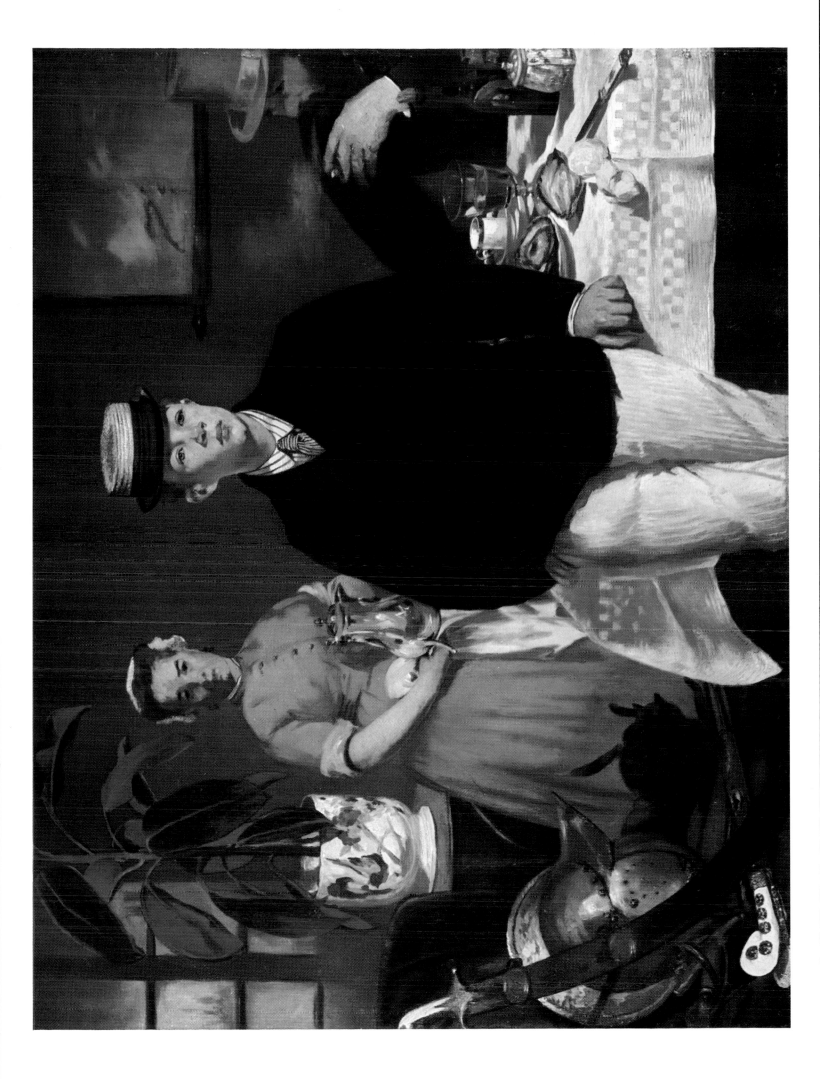

Painted 1868
66 1/2 x 49 1/4 in.
Museum of Impressionism, The Louvre, Paris

The Balcony

This painting was perhaps inspired by Charles Baudelaire, whose famous poem of the same title was written about that time:

Et les soirs du balcon, voilés de vapeurs roses…
(And evenings on the balcony, veiled in pink mists…)

There are no pink mists in Manet's painting, but perhaps the artist was thinking of another line:

Et mes yeux dans le noir devinaient tes prunelles
(And in the dark my eyes found the depths of yours)

when, in the foreground of **The Balcony** he painted Berthe Morisot in Spanish costume. Berthe Morisot, when she saw the work at the 1868 Salon, wrote of Manet, "His paintings give the impression, as always, of wild or even slightly green fruit. I like them very much." Then, speaking of the figure for which she herself had posed, she observed to her sister, "I look more strange than ugly. It appears that the epithet of *femme fatale* has gone the rounds among the inquisitive."

And what of the critics? Louis Esnault, writing in *Le Nain jaune* of May 27, 1869, said that Manet "specializes in horrifying the bourgeois with the deliberate ugliness of his pictures. But people look at them; they stop in front of his **Balcony** with its two horrible bourgeoises in white." Arthur de Boissieu wrote in the *Gazette de France*, "M. Manet, who is still competing with the illustrators of Epinal, is one of those painters who would be better unknown." Théophile Gautier's judgment in *L'Illustration* is scarcely any sounder: "The Balcony, with two green shutters (of the same green that Rousseau wanted the shutters on his dream house to be) thrown back against the wall, reveals in its bluish-gray shadow two girls dressed in white, one seated and the other standing putting on her gloves. Behind them is a gentleman, some young man about town, painted in half-tones that take away the whole of the modeling and make him look like a cutout." And Gautier concludes with the absurd remark that Manet "could become a good painter if he were willing to take the trouble."

The **Balcony** is sulphur-green, the verdigris of watering cans, one of Manet's favorite colors. Though Mlle Claus (the girl standing) seems to be slightly affected, one senses great depth of character in the eyes the artist has given Berthe Morisot, the very gifted painter who married Manet's brother Eugène. As for the man with the cigarette, he is quite at ease, offering himself complacently to the gaze of passersby. The whole canvas is pervaded by the satin-smooth whites with slightly bluish tints that are to be found only in Manet.

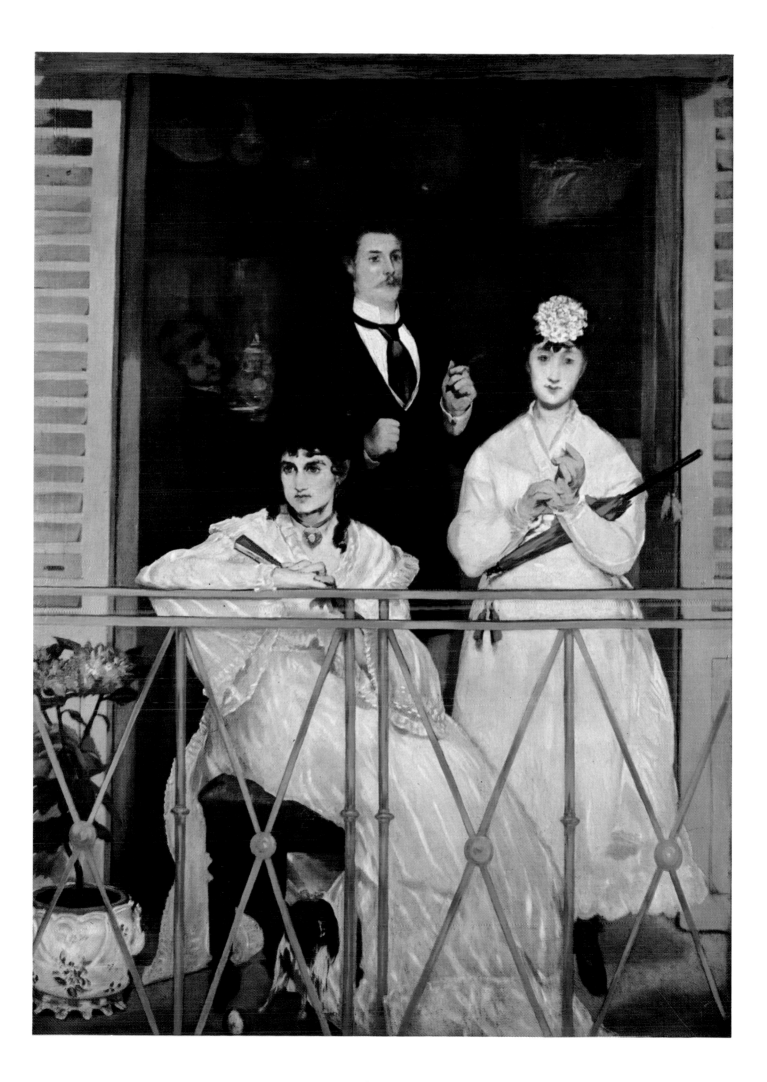

Painted 1869
23 1/4 x 28 in.
Collection Mrs. Carroll S. Tyson, Philadelphia

Departure of the Folkestone Boat

The freedom of execution of this painting approaches abstract techniques. Everything is suggested by spots of color that flicker against the calm expanse of the background. The palette is still finely balanced between black and white, with highlights in blue, red, and yellow, set off by the blue-green of the sea beneath the clear sky. We are now familiar with Manet's technique; it is difficult for us to imagine how unconventional and impudent his manner of sketching figures with a few brush strokes once seemed. Conformists simply could not understand that what appeared formless at close quarters took on relief and detail at a distance. It is enough simply to look closely at this picture and then to move away from it to be impressed by Manet's incomparable power of suggestion, in which he excelled every other painter of his day.

Manet was improvising in this picture. Twenty years before he had spent several months on a training ship and was familiar with the sea and ships. He seems to have forgotten much since then. I doubt that a captain ever stood on his bridge quite as Manet has shown here. At the left of the group of passengers we can see Mme Manet, holding a parasol, and Léon Koëlla-Leenhoff, in a felt hat with a feather.

The picture was painted from the window of the Folkestone Hotel in Boulogne. Manet stayed there a week without doing any work. Then, according to Tabarant, he took the steamer across the Channel on a sudden impulse and rushed up to London, where he was welcomed by the painter Alphonse Legros and Mr. Edwards, a connoisseur. Six days later, he returned to Boulogne, "enchanted with London," as he wrote Fantin-Latour. He began to paint, certain henceforth that what the realists in Paris regarded as his faults constituted in fact his true personality. He painted seven pictures, of which this was one. The sketch for it is in the Oskar Reinhart collection in Winterthur. Manet sold this canvas to Durand-Ruel in 1872.

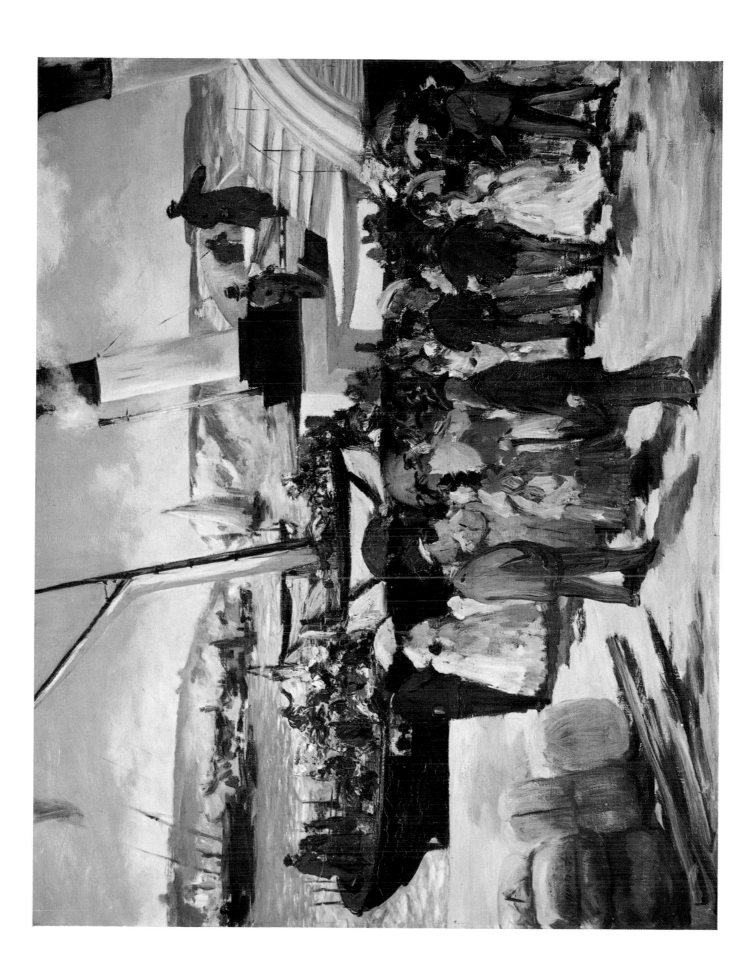

Painted c. 1870–71
58 1/8 x 44 1/2 in.
Museum of Art, Rhode Island School of Design, Providence

Repose
(Berthe Morisot)

Manet had imparted the spirit of modernism to the face of Berthe Morisot when she posed, with her mother's permission, for **The Balcony** (page 83). He was to paint her often: in a black hat, almost smiling, fascinating under her veil of mourning; or mysterious, her face hidden behind a fan; and here, seated on a divan, at ease, with her arms flung out.

Manet, however, never had the ascendancy over this distant relative of Fragonard that he had during the same period over Eva Gonzalès, who was to become his pupil. Berthe Morisot stood up for herself and argued hotly. "I agree with you," wrote Fantin-Latour to Manet on August 26, 1878, "the Morisot girls are charming. It is a pity they are not men. However, as women, they could further the cause of art by each marrying an academician and stirring up trouble in the camp of those old fogeys." Berthe was to do better than that. She was to become one of the most sensitive and important painters of the century, leaving far behind the writer of those jesting lines, who was to sink into a morass of symbolic musical illustration.

This portrait, which elevates the particular characteristics of the individual to the universal image of a woman resting, was the butt of numerous jests directed against its bold, decisive technique when it was displayed at the Salon in 1873. *Le Charivari* on May 15, gave an account of a fictitious National Assembly of Fine Arts, with Corot as President:

M. Manet goes to the rostrum. (*Titters and whispers.*)

"Gentlemen, I am most embarrassed. My colleagues of the sixth committee thought it would be amusing to have me report on the election of M. Robinet [Gustave Paul Robinet, a landscape artist and a pupil of Meissonier], so justly nicknamed the Raphael of the pebble. This painter sees everything on a small scale, just as I see everything on a grand scale. In his work, detail kills the whole; in mine, as you must have noticed, the opposite is true. (Cries of 'Hear, hear!') Nevertheless, I shall endeavor to carry out my task with all due impartiality. (*Applause.*) The tonality of The Olive Grove is all right, but the background has been rendered in a cold, dry manner that emanates perhaps from the excellence of the artist. It is said that he was found one day on the Concorde bridge counting the facets of the eyes of a fly poised on the tip of the Obelisk!" (*Incredulous laughter.*)

It was a fact that the hidebound traditionalists of the day thought that Manet's work was too sketchy and lacked respect for detail. The lovely Berthe Morisot was scarcely flattered in the criticism of the painting. "This slut in a white skirt, flopping on a couch, might be sleeping off her wine," commented one contemporary newspaper. Nonetheless, **Repose** heralded the broad planes found later in the work of Bonnard and the Nabis.

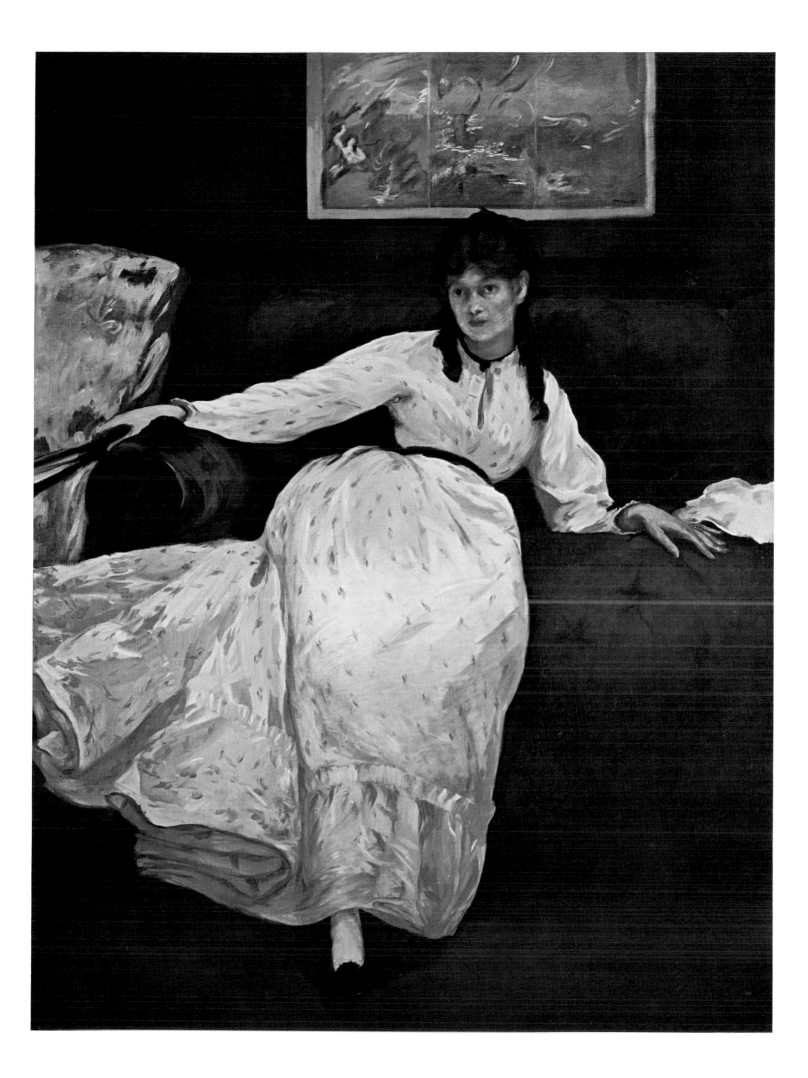

Painted 1870
75 1/4 x 52 1/2 in.
The National Gallery, London

Eva Gonzalès

The only pupil Manet ever really trained is shown here in his studio, painting a still life of flowers. A white camellia lying on the carpet accentuates the bluish tints of the white dress, which Eva Gonzalès wears here without the customary covering of an artist's smock. She looks very feminine in this picture—more like an amateur artist in comparison to Berthe Morisot. This impression is strengthened when one looks at her **Box at the Théâtre des Italiens**, a good painting, to be sure, and then at the **Young Girl at the Ball** by Morisot, which is far superior. (The Morisot painting, which hangs adjacent to the Gonzalès in the Louvre, was purchased by the French Government in 1894, at the instigation of Mallarmé.)

To return to Manet's picture, we see the pupil, with her great, dark eyes, posed at her easel against a duck-green background. Eva Gonzalès was the daughter of the novelist Emmanuel Gonzalès, who wrote for *Le Siècle* and had been the President of the French Society of Authors since 1863. She studied under Chaplin before becoming Manet's pupil and starting work in his studio in 1869. Manet began her portrait almost immediately. She had been introduced to him by the Belgian painter Alfred Stevens. She was twenty years old. Although begun early in 1869, the painting did not satisfy Manet for some time, and he did not finish it, according to Tabarant, until March 12, 1870.

It was exhibited with the **Music Lesson** in the Salon of 1870. *Le Tintamarre* on May 29 gave it the following accompanying dialogue:

> Visitor: I must have that.
> Friend: Bah! How much do you think you'll have to pay for it?
> Visitor: Oh, a hundred francs.
> Friend: You're joking—the frame alone is worth a hundred fifty!
> Visitor: Yes, but then, you see, it has the picture in it.

Berthe Morisot, who called on Manet at the time (she was posing for **Repose**, page 87), wrote to her sister, not without a slight tinge of jealousy: "Manet lectures me and holds up that everlasting Mlle Gonzalès as an example.... Meanwhile he is starting her portrait all over again for the twentieth time."

Eva Gonzalès married Henri Guérard in 1879. She died of an embolism on May 5, 1883, shortly after giving birth to a son. A few days earlier, when she heard the news of Manet's death, she herself had made a wreath for his grave.

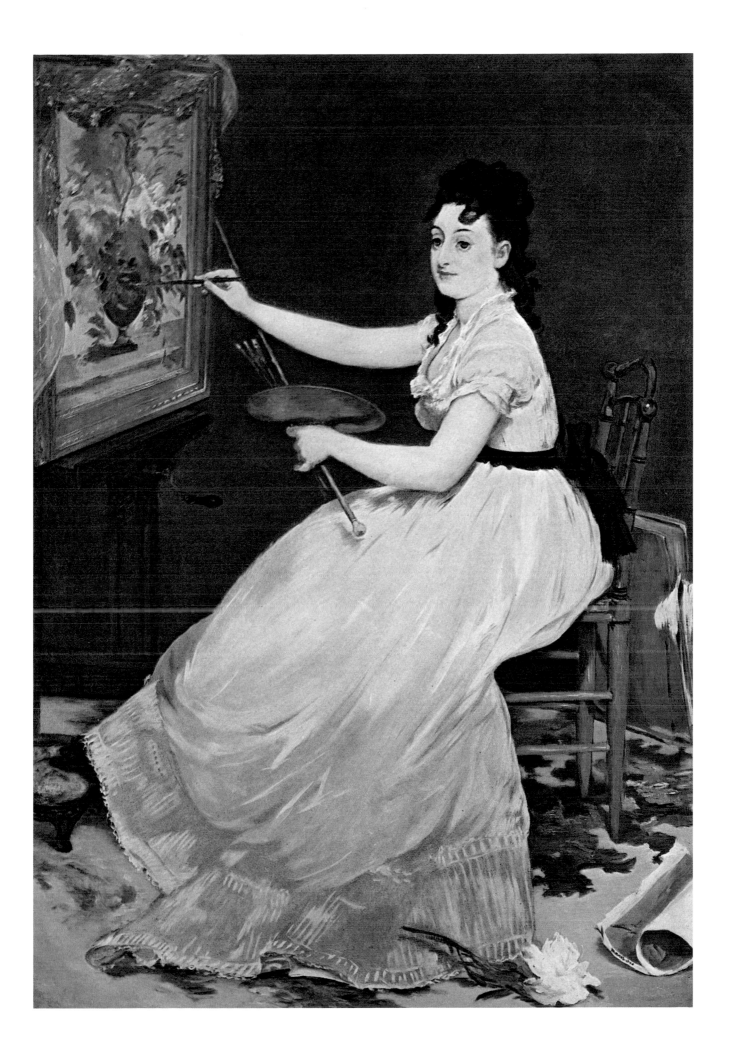

Painted 1873
22 1/2 x 28 3/8 in.
Collection Dubrujeaud
(Pledged to the Museum of Impressionism, The Louvre, Paris)

On the Beach

This picture, posed by Mme Edouard Manet and Eugène Manet at Berck in the summer of 1873, is a brilliant example of Manet's rapid brushwork and his gift for immortalizing the instant. Looking at the warm beige of the fine sand, one becomes a witness to the passage of time, while the waves on the shore below beat out the measure. The sea, with boats running full sail before the wind, reaches almost to the top of the picture. This is Manet at his finest—with his delicate shades of gray, Parisian gray, and his deft brushwork, which with a few strokes suggests the foam of the waves breaking on the beach.

Above all, this picture shows Manet's remarkable gift for placing his accents. The whole effect would be sketchy, fluid, and woolly were it not for the touches of black or blue-gray that make the figures stand out unforgettably from their background. The whole atmosphere of the picture is one of repose, relaxation, and leisure. It is like one of Debussy's evocations in music, and actually, there is a close artistic similarity between the composer and Manet. The deep black of Mme Manet's bonnet strings has the same emotional power as the bright chords that run through Debussy's compositions.

This memorable work justified the penetrating comments of Jacques de Bietz on Manet in 1894: "An artist to the very core, an artist in his faults, an artist even in his omissions, entirely wrapped up in himself, absorbed in recording his impressions in the changing skies of his emotions, he lived only to give expression to the idea that possessed him, the idea of light."

Manet worked for three weeks at Berck, where he had rented a house. It was there that the marriage of his brother Eugène to Berthe Morisot was first considered.

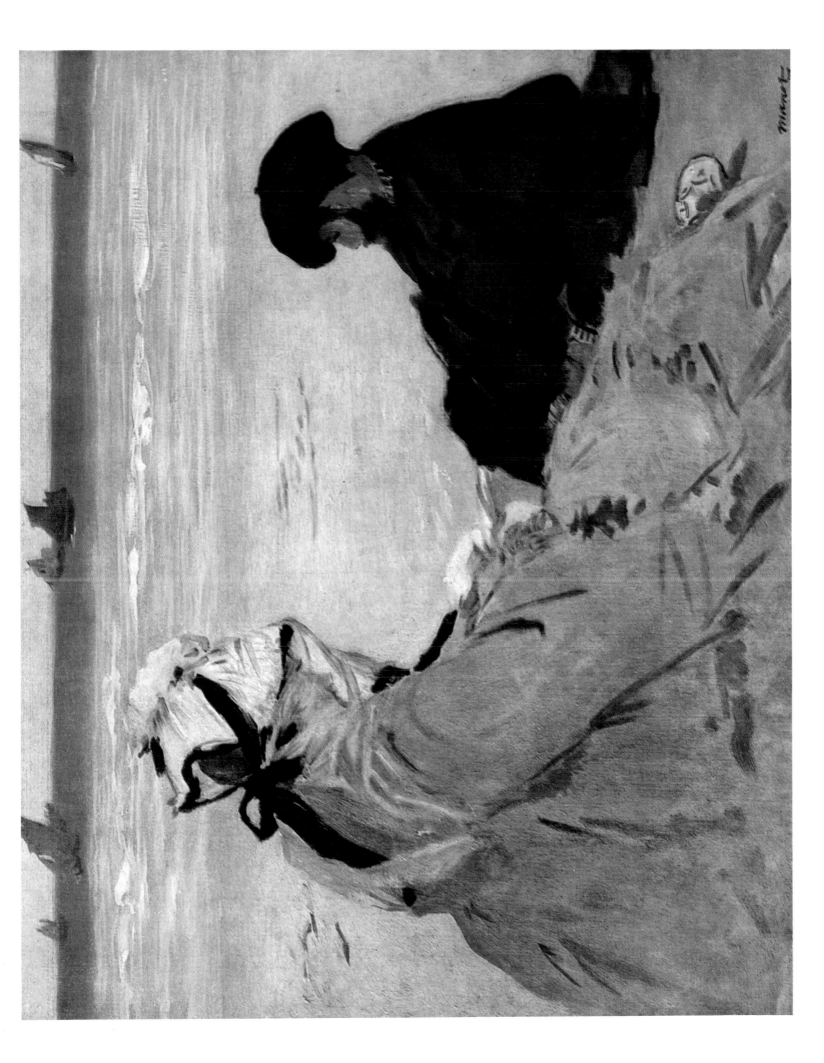

Painted 1873
22 1/2 x 28 3/8 in.
National Gallery of Art, Washington, D.C.
(Gift of Horace Havemeyer, in Memory of His Mother Louisine W. Havemeyer)

Gare Saint-Lazare

Those who know the seventeenth arrondissement of Paris will recognize the railway line still to be seen between the Place de l'Europe, the boulevard des Batignolles, and Mallarmé's house in the rue de Rome. This picture is a well-observed slice of reality. The tone is exquisitely light, and the little girl's blue bow is a marvel of art. The most admirable thing of all is that we do not see the train that the child is watching with such evident delight. It is merely suggested by the smoke rising behind the bars.

When hung in the Salon of 1874, this picture was admired by Castagnary, the champion of Courbet, who was often unjustly critical of Manet. The critic of *Le Siècle* described it as "powerfully luminous" and "distinctive in tone." No doubt it was partly the subject that appealed to this devotee of the realist school.

This favorable reception did not prevent *Le Tintamarre* from publishing on May 10 the following doggerel verses, to the effect that the painting was the work of a madman and depicted the railway to the insane asylum (Charenton):

Ce tableau d'un homme en délire
a, pour étiquette, dit-on,
"Le Chemin de Fer," il faut lire:
Chemin de fer pour Charenton.

Le Charivari of May 6 adopted the same mocking tone:

M. Veuillot: It is a case of acute pictorial delirium.
The Executioner: Shall I...?
M. Veuillot: Yes.
(The executioner strikes furiously at the bars of the cage.)
The Little Girls (*laughing*): Bad luck! You can't get at us. Papa Manet made the bars enormous!

Fortunately, there was Philippe Burty to take up the challenge. In *La République Française* of June 9, 1874, he praised "the blue twill frock of the seated young mother. [Victorine Meurend was the model.] Above all, we recognize M. Manet's desire to strike the right note without the help of any artifice of style or pose and his application to painting out of doors.... He has been much criticized, even insulted, but no one can deny the influence of his system on the real artists of his group."

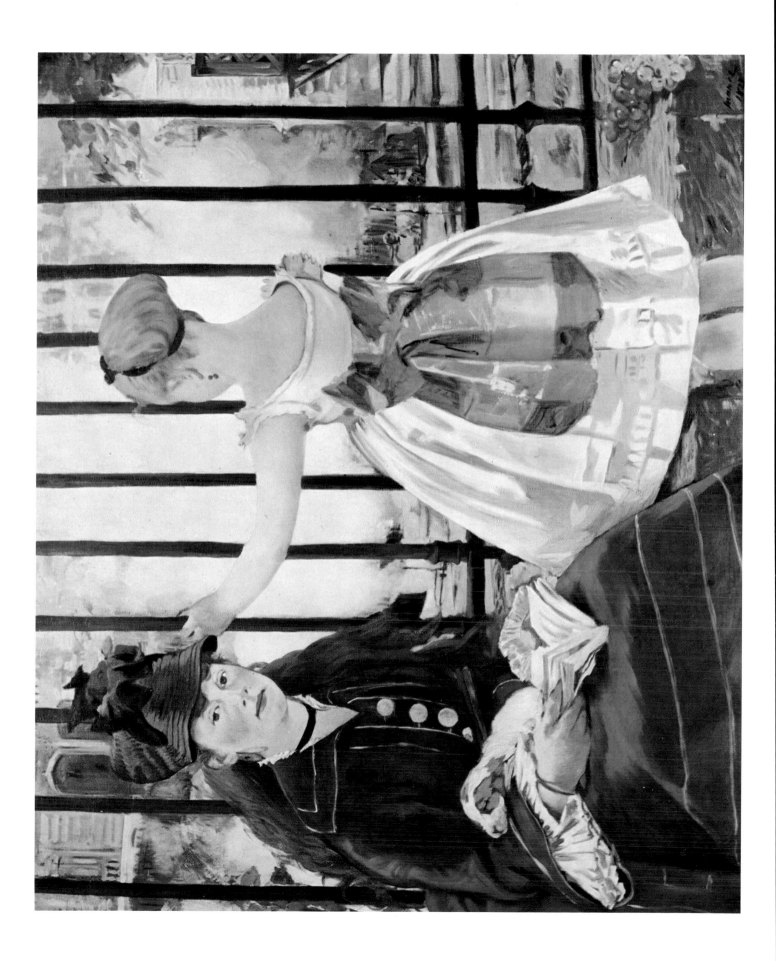

Painted 1894
57 7/8 x 44 1/2 in.
Museum of Fine Arts, Tournai, Belgium

Argenteuil

With its golden tonality bathed in light, this canvas is without doubt Manet's sunniest painting, the great work to which Renoir replied seven years later with his **Luncheon of the Boating Party**. Everything in the picture pulsates with the fullness of life. This is the miracle of the open air and the zenith of Manet's incomparable touch. Each detail—the village trailing away in the distance, the river banks, the trees, the brick and stone houses, the Seine, whose rich blue was so often ridiculed, the play of light and textures in the clothing, and the figures, carved, it would seem, out of the heat of the day—contributes to make **Argenteuil** Manet's greatest outdoor painting. The canvas exalts light, color, and technique with the most vivid intensity. It has the inevitability, vibrancy, and vitality that, applied to literature, made Guy de Maupassant a great writer. It sums up, without metaphysics, the character of Manet—his simple joy of being alive, which none knew better than he.

The scene of the picture is actually Petit Gennevilliers, which at that time, rather than Argenteuil, was the favorite meeting place of boaters. Manet felt quite at home there, since his cousin De Jouy, the lawyer, had a house there. The topographical precision of the title shocked the unimaginative. "He forgets Argenteuil and geography..." wrote Paul Mantz in *Le Temps*, "he makes the Seine into a madly blue Mediterranean.... He thinks of color harmonies much more than of presenting the truth about the place he is painting." The critic of *Le Gaulois*, on June 22, 1875, saw in Argenteuil nothing but "a wretched daub."

Manet's first serious attempt at open-air painting was **The Garden**, painted in 1870 at the country home of his friend and colleague Joseph de Nittis, in Saint-Germain. That work, however, does not have the extraordinary brilliance of Argenteuil. In his book on Manet, Jacques de Bietz described the revolution provoked by Manet's innovations:

> From the moment Manet set himself up as the official exponent of outdoor color, he was more decried than ever. We must realize that this rebel was up against a century of habit, and that in order to free the light within himself, he deliberately broke the stale, yellowed panes of chiaroscuro. Suddenly, without warning, he flashed a magnesium lamp in our faces and all but blinded us. Naturally he was hated for it.

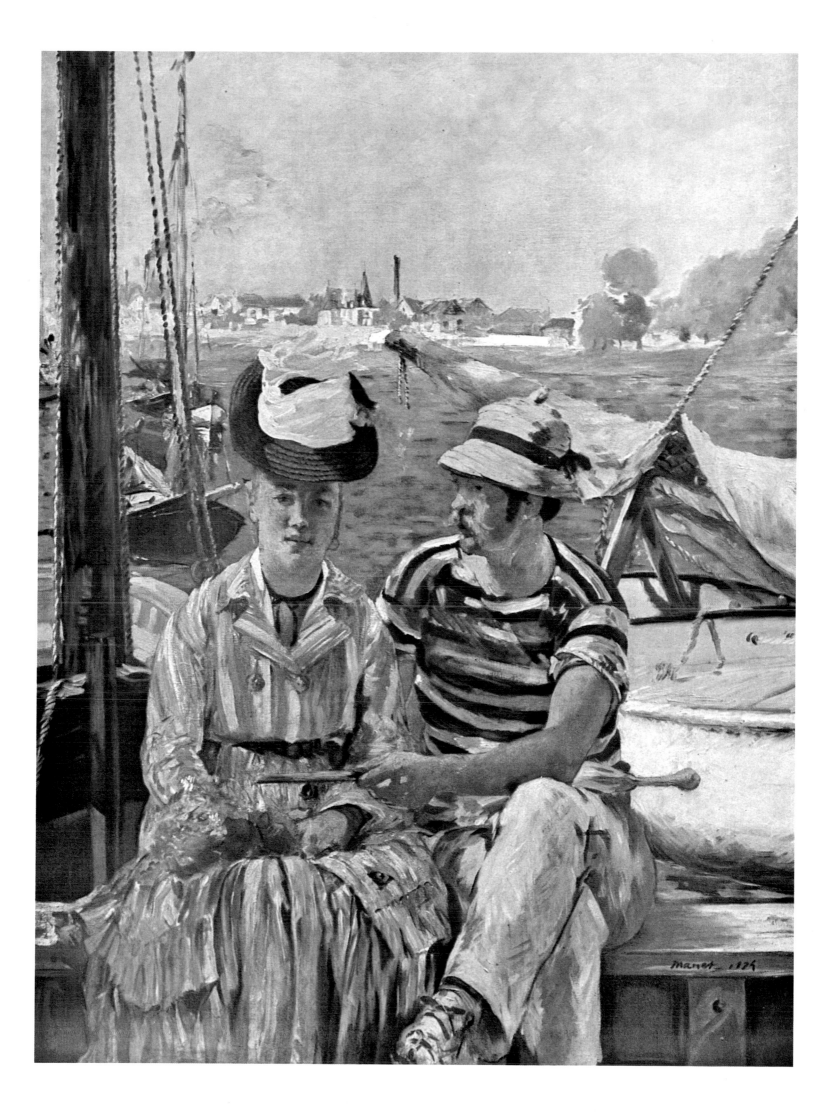

Painted 1874
32 1/4 x 39 3/8 in.
Bavarian State Painting Collections, Munich

Monet Painting in His Studio Boat

This is the boat on which Monet used to paint at Argenteuil, where he lived in 1874. This work, executed rapidly and signed on the boat itself, raises for the historian the question whether Manet or Monet was the first to paint outdoor pictures in the Impressionist sense of the term, that is to say in the full light of day. It would seem that it was Monet with **The Picnic**, 1865–66, who first let the light play among the branches and outlined his figures with patches of sunlight.

While he was working in his floating studio, Monet was very short of money and was obliged to ask for help. "Here I am again without a *sou*," he wrote to Manet, asking for a loan of fifty francs one day, twenty francs another. "I have got into the hands of a bailiff who can cause me a lot of trouble. He has given me until midday." Manet was generous, as usual. Antonin Proust says that in his studio he placed his friend's canvases in a good light, being anxious to find buyers for them and not troubling about his own. Claude Monet's pictures enjoyed his special favor at these exhibitions. He had painted Monet on a boat and was particularly fond of this canvas, which he called **Monet in His Studio**.

Monet worked on this old boat, which he had bought secondhand. He rowed or punted it along the river and stopped as the fancy took him. His wife cooked simple meals, and the couple entertained their friends on board.

As for the technique of this painting, Jacques de Bietz wrote, "It was by means of touches of light that Manet penetrated Nature's secrets and divined her elusive charms. He had an admirable sense of the values of foreground, middle ground and background and never made a mistake in their relation to one another. He would take as many as three shades on the tip of his brush in order to be sure, when he put on his paint, of a subtle rendering."

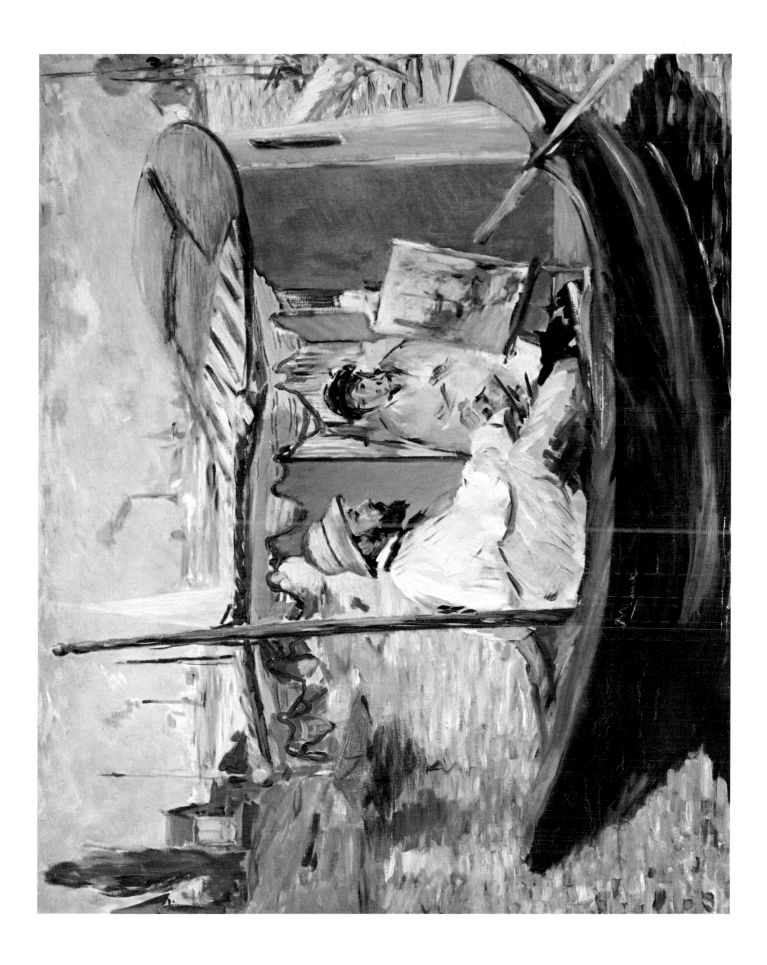

Painted 1875
76 x 51 1/8 in.
Museu de Arte, São Paulo, Brazil

The Artist
(Marcellin Desboutin)

Like the portrait of Duret, the portrait of Desboutin depicts an entire personality. It can be called **Artist with a Dog** without losing its meaning, for Manet has succeeded in generalizing his theme. Without making his subject one of Murger's bohemians, Manet has given him an air of hovering between reality and poetry, with a feeling for life in all its forms from the gutter to the chateau that was characteristic of Desboutin, half-proletarian, half-aristocrat. Untidy in his dress, highly cultured, painter, etcher, illustrator, and poet, Desboutin was above all a dilettante.

The portrait is well posed. The man in blue, filling his pipe as he walks towards us, while his dog tries to drink out of a glass too small for his muzzle, seems a familiar figure. He is alive—at once an artist and a loafer, a thinker and a buffoon. Such was Marcellin Desboutin. He had a studio in the Batignolles quarter on the rue des Dames, at the back of a courtyard "filled with the noises of carpentry and metal-working," as Edmond de Goncourt described it. He was a fanatical royalist, and at the Café Guerbois and later at the Nouvelle-Athènes where he had his table, he would hold forth, while smoking, in defense of the Comte de Chambord. A year after this portrait was painted, Degas had Desboutin pose with Ellen Andrée outside the Nouvelle-Athènes for **Absinthe**.

The Artist and **The Laundress** were rejected by the jury of the 1876 Salon. (People called the Desboutin picture the portrait of a coalman.) Manet decided to exhibit it himself, with other rejected works. He held an exhibition from April 15 to May 1, from 10 a.m. to 5 p.m. at 4, rue de Saint-Péters-bourg, on the ground floor. His slogan was, "Do what is true and let them talk." Greatly excited, the art students of the Nouvelle-Athènes hung a strip of calico under the studio windows during the night, with the inscription: "Choice of the rival jury."

People flocked to the exhibition; it was a great success. All the avant-garde writers and artists of any repute were there, with Méry Laurent and Victorine Meurend, Manet's models. "Manet's name is on everyone's lips," reported *Le Figaro* on April 19. "The rejection of his pictures by the jury has made him a victim of persecution, and the crowd is at last about to admit that he has talent."

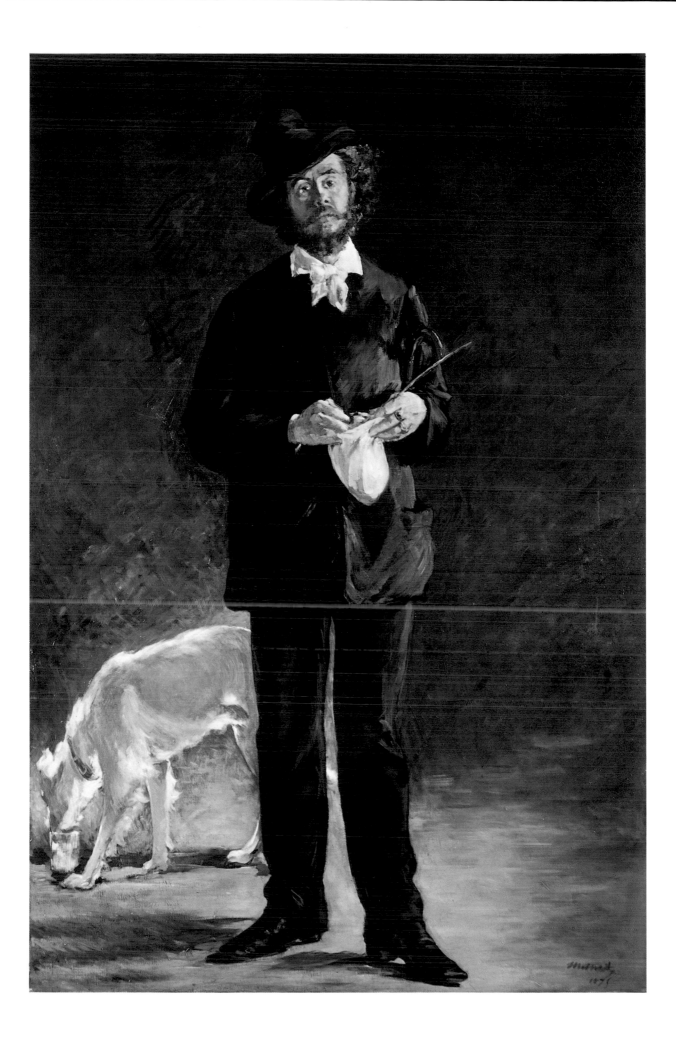

Painted 1876
10 1/4 x 13 3/8 in.
Museum of Impressionism, The Louvre, Paris

Portrait of Stéphane Mallarmé

It appears that Manet must have known Mallarmé before 1873, when it is commonly thought they first met; this seems clear from a letter by Félicien Rops to Manet. In *La Renaissance* of April 12, 1874, Mallarmé published an article in Manet's defense against the jury of the Salon. This article established a close friendship between the artist and the poet. Mallarmé wrote of Manet's rejected works, "The crowd from whom nothing is hidden, since it is the source of all things, will recognize itself one day in the many works that survive, and, when that time comes, all that has gone before will be totally forgotten. To gain a few years on M. Manet—what a poor policy!"

In his *Souvenirs*, Antonin Proust recalled meeting Mallarmé for the first time in Manet's studio in the rue de Saint-Pétersbourg: "He was then young and handsome. He had large eyes, a straight nose above a thick moustache underlined by the clear accent of his upper lip. His thick hair crowned a high, prominent brow. His beard ended in a sharp point against a dark cravat.... We talked of the poems of Edgar Allan Poe, which he had just translated and for which Manet was then doing the illustrations [figures 67 and 68]."

Mallarmé was thirty-four when Manet painted him. What an admirable little portrait! The poet lies back at an angle in an armchair. Manet shows him with an enigmatic look in his eyes, widely spaced eyebrows, and deliberately disheveled hair. He holds a lighted cigar in one hand, which rests on a manuscript, and the other hand he has slipped casually into his pocket. He seems to be waiting to see his own image.

When I look at this portrait—so different from the pale vision of the same man by Whistler, who saw Mallarmé as the author of "La Pipe" and the poet of "beloved mists"—I admire its freshness, its body, and its vital reality.

Originally painted on a canvas measuring 10 1/4 x 12 5/8 in., the portrait was enlarged by Manet before its completion "by means of a strip three-quarters of an inch wide sewn on to the right-hand side, thus giving it its present dimensions." The painting was not shown in public until the posthumous exhibition in 1884.

Painted 1877
60 5/8 x 45 1/4 in.
Kunsthalle, Hamburg

Nana

Tightly corseted in blue satin, wearing blue stockings and a transparent petticoat, Nana stands poised with considerable aplomb. She is reddening her lips before the mirror and holds a powder puff ready in one hand. A gentleman in evening dress, to whom she listens somewhat absent-mindedly, is seated on a sofa at the right-hand edge of the painting. The background is formed by a luminous Japanese hanging that shows a crane walking on a sandy shore. This is a work of plain, unvarnished realism, without a trace of coarseness or bad taste. Gustave Geffroy wrote of the picture, "Everything in it speaks of the faubourg and the boulevard, the triviality and the vice of Paris, and the whole is rounded off by the figure of the man, who has stepped into the scene out of the high life of the city."

"It is she! It is Nana! Painted by Manet after Zola!" said *Le Tintamarre*. This remark has caused some confusion. The critic doubtless meant that the painting's crude realism was inspired by Zola's writings. The novel *Nana* did not begin serial publication in *Le Voltaire* until October 1879, two years later. However Nana had already appeared as a character in *L'Assommoir*. Huysmans pointed out the literary allusion in an article in *L'Artiste* of May 13, 1877:

> The painting of Manet's that the 1877 jury rejected has just been hung in Giroux's window. Needless to say, there is a crowd in front of it all day long, and it provokes the indignation and laughter of people stultified by prolonged contemplation of the window shades that Cabanel, Bouguereau, Toulmouche, and others feel obliged to daub with paint and hang on the wall every spring. The subject of this picture is Nana, the Nana of L'Assommoir, powdering her face with rice powder.... Manet was quite right to offer us in his Nana one of the most perfect examples of the type of girl that his friend, our revered Emile Zola, is going to depict in one of his forthcoming novels.

From this we can see that if Zola inspired Manet, Manet in turn was to inspire Zola by this symphony of browns and blues, this glorification of woman.

Painted 1878
29 1/8 x 19 1/4 in.
Collection Mr. and Mrs. Arthur Sachs

The Tipsy Woman

With the **Tipsy Woman**, one of his finest works, Manet continues the naturalism of **Nana** (page 103). The subject might be compared to Degas's **Absinthe**, painted the year before in the same setting of the Café de la Nouvelle-Athènes. There is a dazed feeling about the painting. The style is bold with some very delicate touches, for example, in the hand holding a cigarette. The palette is a subtle harmony of mauves and pinks. The sureness of touch, the poetry, melancholy, expectancy, and understanding of women evident in this canvas recall what Zola said of Manet, "The first thing that strikes me in his paintings is the delicate precision in the harmony of his tones."

Under the guise of this almost anecdotal subject Manet has depicted all the sadness and discouragement, all the emptiness of soul of the disappointed and solitary woman. This figure is a magnificent example of Manet's gift for suggesting the inward reality by painting the outward appearance. A few colors, a few smudges, some firm touches here and there are all that he needs to convey a mood. It is as if the texture of the paint, the colors, and the brush strokes had emotions of their own to convey to us.

In March 1899, Renoir wrote, "Deudon [who had bought the picture from Manet in 1882] has been offered as much as he likes for Manet's woman with the plum…. It is quite funny to see his delight."

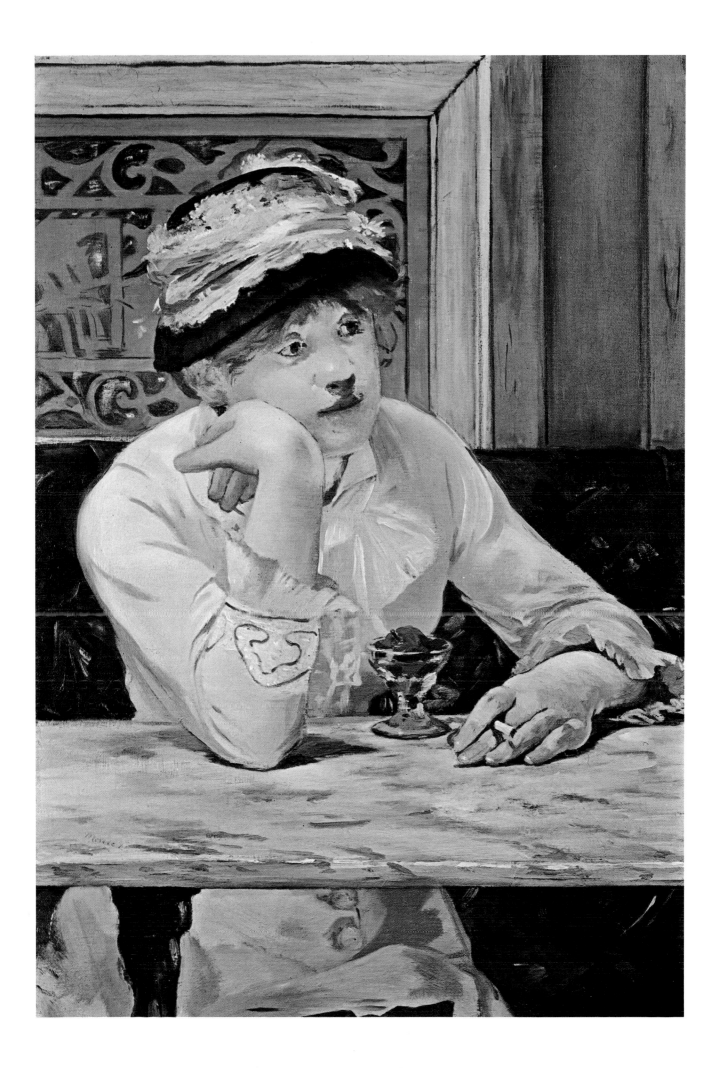

Painted 1878
24 1/2 x 20 in.
Museum of Impressionism, The Louvre, Paris

The Blonde with Bare Breasts

Manet is one of the greatest painters of women and the female body. Breaking with the academicism of the schools and successful artists, he began by presenting us the fresh nude form of Victorine Meurend in **Luncheon on the Grass** (page 60). Then he painted **Olympia** (page 63), using the same model. By academic canons, she is a monstrosity, but there is something naïve and startling about her, some-thing which touches a new chord in the onlooker. After that, Manet painted few nudes until 1872, when he painted the **Brunette with Bare Breasts**, posed by a model he used only occasion-ally. The **Brunette** lacks the physical appeal of the **Blonde**, which was painted in the studio lent to Manet by the Swedish artist Rosen. The model's name was Marguerite. She also posed for the **Tub** and the **Woman with a Garter** (figure 43). Tabarant talks of her "chubby little face" and wonders how Moreau-Nélaton could have taken her for Ellen Andrée.

The flesh tints are magnificent. The pearl glow of the skin has been admirably set off by the pale green background. With a sure hand, the artist has added a few finishing touch-es of aerial lightness. The pink and white body is bathed in light and resembles, as Gustave Geffroy wrote, "flower and fruit—an exquisite evocation of living and perishable flesh."

After the **Blonde with Bare Breasts**, Manet executed a number of pastel portraits of the women who came to see him at Bellevue, Rueil, Versailles, and in his home in Paris. To our eyes, this last series of portraits—heiresses, young girls, actresses, and models—is a lingering farewell of the artist to womankind.

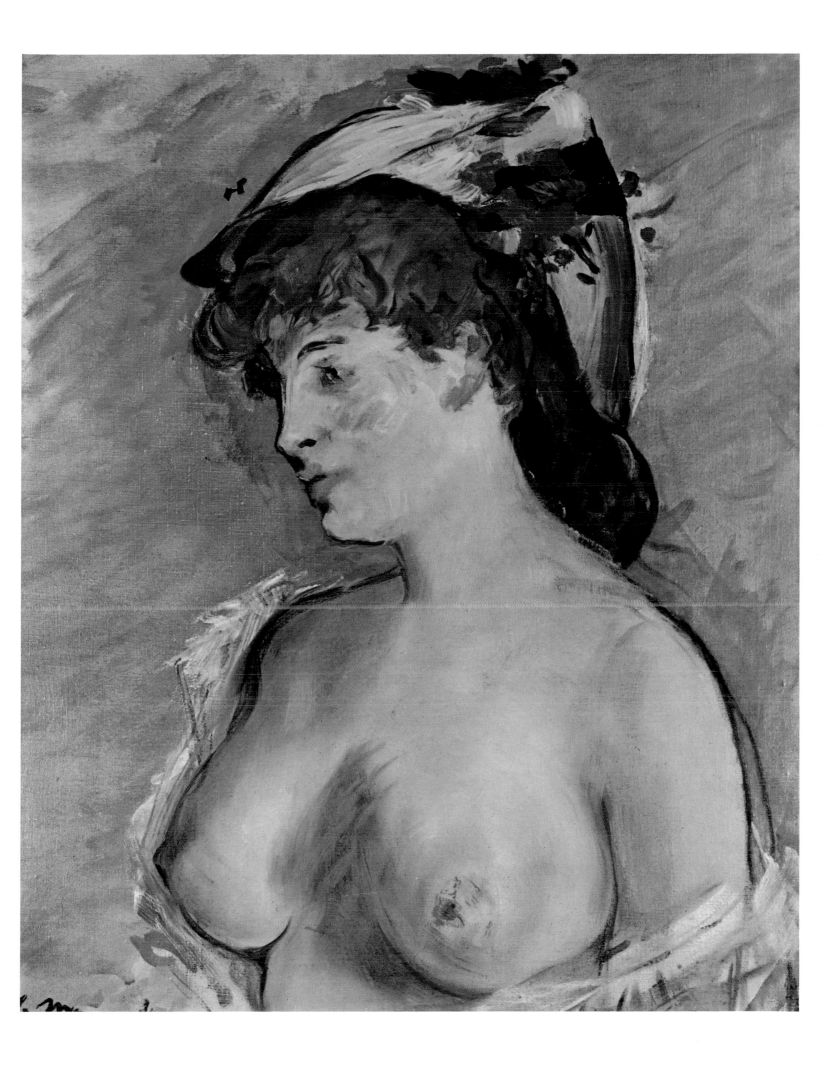

Painted 1878
24 1/2 x 31 3/4 in.
Collection Mr. and Mrs. Paul Mellon

Rue Mosnier Decorated with Flags

It is not to celebrate the fourteenth of July that these flags hang so gaily in the rue Mosnier (now rue de Berne). In 1878 the Government decreed a public holiday on the thirtieth of June, and the city was decorated with flags in honor of the Universal Exposition. There had not been any Fête Nationale since 1869.

This painting is characteristic of Manet. It has the broad planes of light so typical of his style, and fine modulations in which the animation of the street is suggested by a touch of blue in the cripple, the hansom cab, and the tricolor flags that punctuate with their lively hues the over-all golden tonality.

This is one of a group of works by Manet which shows the influence of the Impressionists, who held their third exhibition that year. Although his paintings were rejected by the jury for the Exposition, Manet gives proof here of his total objectivity by painting the Exposition flag and making the three colors of France sing out joyously. Everything was to him a potential painting. He executed this scene from the window of his studio in the rue de Saint-Pétersbourg (now rue de Leningrad) on the morning of the Fête Nationale.

There are other paintings of this view, one in the Courtauld Collection in London, called **La Rue Mosnier aux paveurs**, and another in which the left foreground is cut off by one of the flags.

Manet's notebook states that the present picture was sold to Portalis in 1879 for 500 francs, together with the Courtauld painting, which brought 1000 francs.

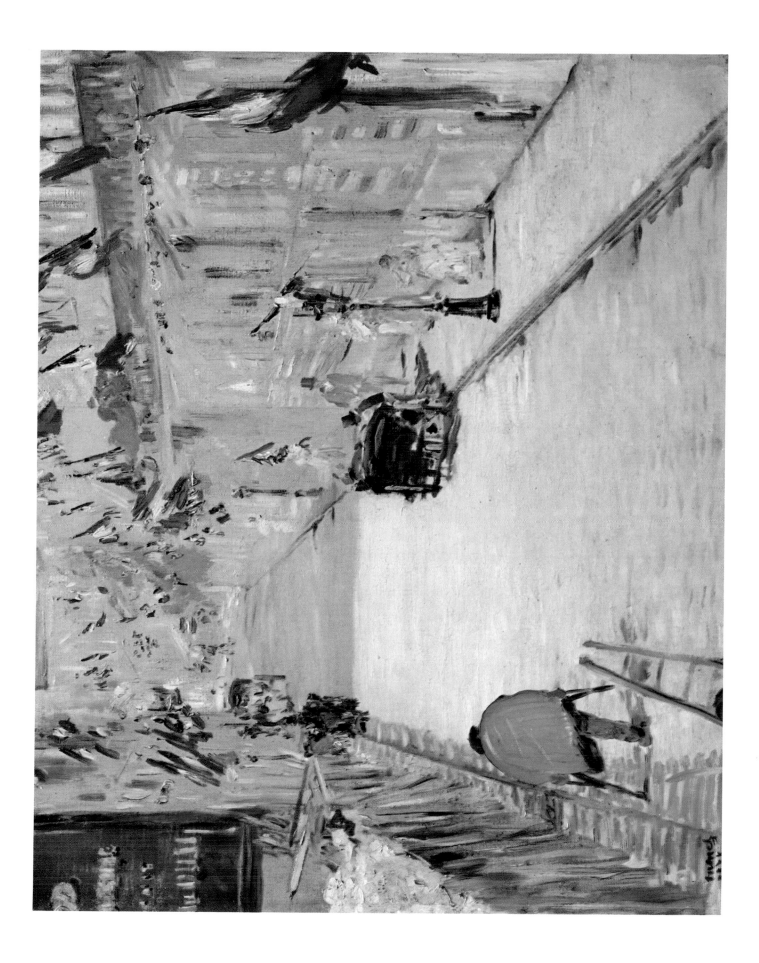

Painted 1878
18 5/8 x 15 1/8 in.
The Walters Art Gallery, Baltimore

Au Café

Among the numerous café scenes painted by Manet, this café-concert is among the most suggestive. With bold, golden strokes that seem to take their color from the beer in the mugs, Manet shows us people looking on while the singer reflected in the mirror sings herself hoarse. Above and beyond the picture of boulevard life it presents, this painting is remarkable for its brilliance and vigor. Manet has painted the hands with great skill and elegance. (It is interesting to note that his treatment of hands is never so fine as when he has not labored over them too much.) The composition itself is a symphony of blues and golds that illuminate the blacks and impart a lively rhythm to the whole picture.

The setting is the Reichshoffen cabaret on the boulevard Rochechouart. The picture is one of a series of similar scenes painted either here or at the Nouvelle-Athènes. The man in the top hat is one of Manet's regular models; he also posed for the watercolor entitled **Punchinello** (figure 30).

Manet liked the atmosphere of cafés and brasseries and often sat in them for relaxation after working. He met his friends there, and most of the knowledge we have of his life and habits comes from the people who used to talk with him or sit near him at the Café Guerbois, Tortoni's, or the Nouvelle-Athènes.

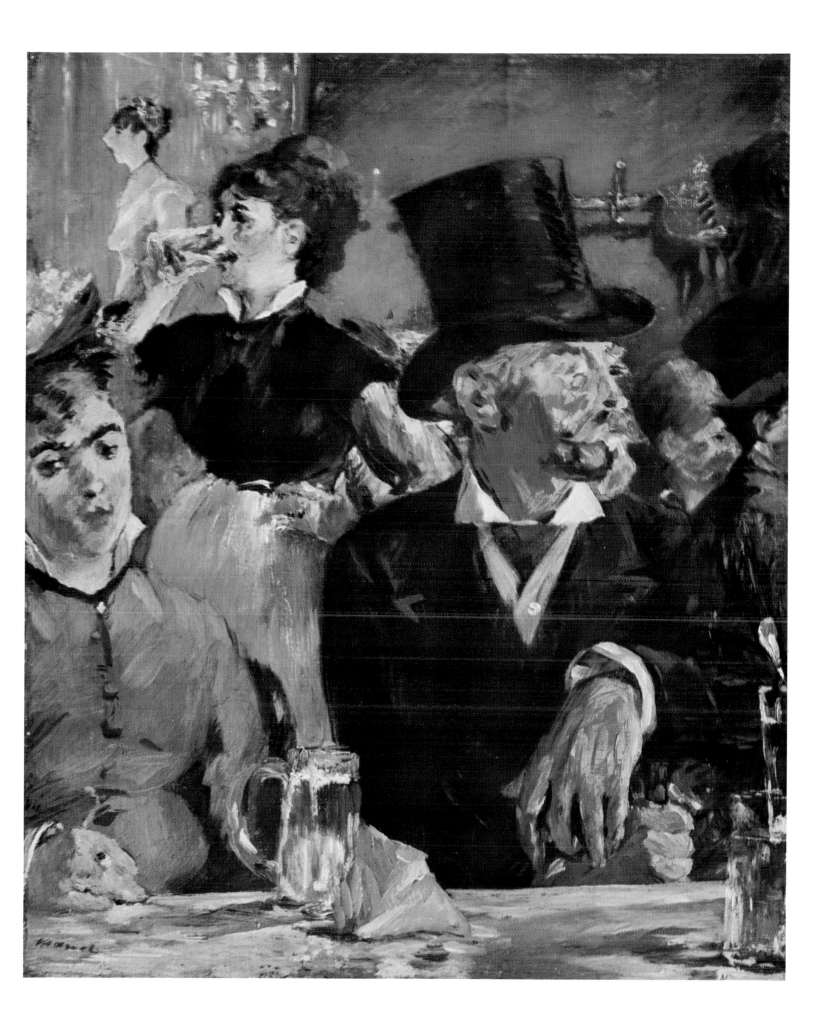

Painted 1879
45 1/4 x 59 in.
State Museums, Berlin

In the Conservatory

This is one of the most delightfully fresh of all Manet's works. It depicts a scene from Paris society life at the time when Alphonse Daudet was publishing his novels. (Could this not be a scene from *Fromont jeune et Risler ainé*?) The artist has succeeded perfectly in this conversation piece, in which the woman is like a dainty flower bright with the first bloom of youth, while the figure beside her, some years older than she, has the handsome worldliness of a man about town. One must admire the way Manet has contrasted the rose tints of the flesh with the ivory tones of the collar and hat worn by Mme Guillemet.

M. and Mme Guillemet, who posed for this picture, were close friends of Manet. She was an American noted for her good taste. The couple ran a fashion house at 19, faubourg Saint-Honoré. Manet painted them in the conservatory of the painter Rosen, who lived at 70, rue d'Amsterdam. He worked there "for more than five months at a stretch," according to Tabarant, from September 1878 until the middle of February 1879. His wife came to make cheerful conversation during the long sittings. "Talk, laugh, move," Manet used to tell his models; "to look real you must be alive." Later, he painted his wife on the same bench.

The work was hung with **Boating** (figure 39) in the 1879 Salon; one critic was stupid enough to call it "a daub." However, Théodore de Banville, the author of *Odes funambulesques*, wrote in *Le National* on May 16, "You expect to hear the lady in gray of In the Conservatory speak, as she sits on a green garden seat beside the gentleman with the tawny beard, who is fascinated by the rich moiré material of her skirt.... The whole picture vibrates with color for the delight of our eyes." The poet then went on to speak of the days when Manet was called "the revolutionary, the bloodthirsty villain, the red specter."

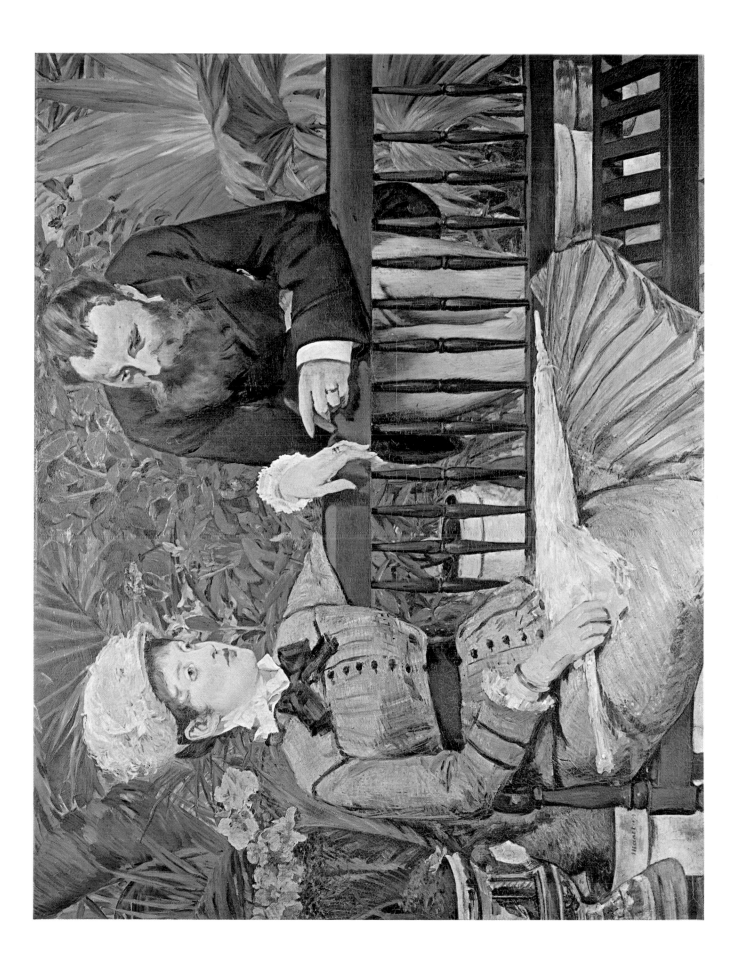

Painted 1879
36 1/4 x 44 1/8 in.
Museum of Fine Arts, Tournai, Belgium

Chez le Père Lathuille

We have before us one of the crowning works of Manet's career. The painter, permitting his talent to blossom forth, has expressed his whole art in this canvas. It is one of those pictures in which time has been evoked like a melody underlying the color. I admire the restrained emotion which gives the painting this lyrical quality.

The picture was painted at the restaurant Père Lathuille, an old establishment near the Clichy tollhouse. (Its sign appears in a picture by Horace Vernet.) In Manet's day, the restaurant was near the Guerbois, off the avenue de Clichy. The model for the woman was Mlle French, who took over from the original model, Ellen Andrée, when she had to break off the sittings. The young dandy is the son of the proprietor, M. Gauthier-Lathuille. Tabarant knew him later when he had turned the old restaurant into a café-concert, the Eden. It was then that Gauthier-Lathuille told him the story of Manet's painting. He had met Manet at his parents' restaurant while he was a volunteer in a regiment of dragoons. He was to have posed in uniform with Ellen Andrée, who was at that time still very young, charming, amusing, and beautifully dressed. After two sittings the picture was progressing very well, but at the third—no Ellen Andrée. She begged to be excused: she was rehearsing a play. Two days later, she met with a rather cool reception from Manet, who said that if that was how things stood, he could do without her. "The next day," recounted Gauthier-Lathuille, "I saw Manet come in with Mlle Judith French, a relative of Offenbach. I took up my pose again with her, but it was not the same thing. Manet was fidgety. 'Take off your jacket and put on mine,' he said to me at last, handing me his own jacket of tussore silk. He then began to scrape the canvas, and thus it was decided that I should pose in civilian clothes with Mlle French."

In this work Manet does wonders with the dress of his day. And yet, says Edmond Bazire, people made fun of the woman's dress and the man's hair. Did they expect Manet to paint Mme de Pompadour and a guardsman?

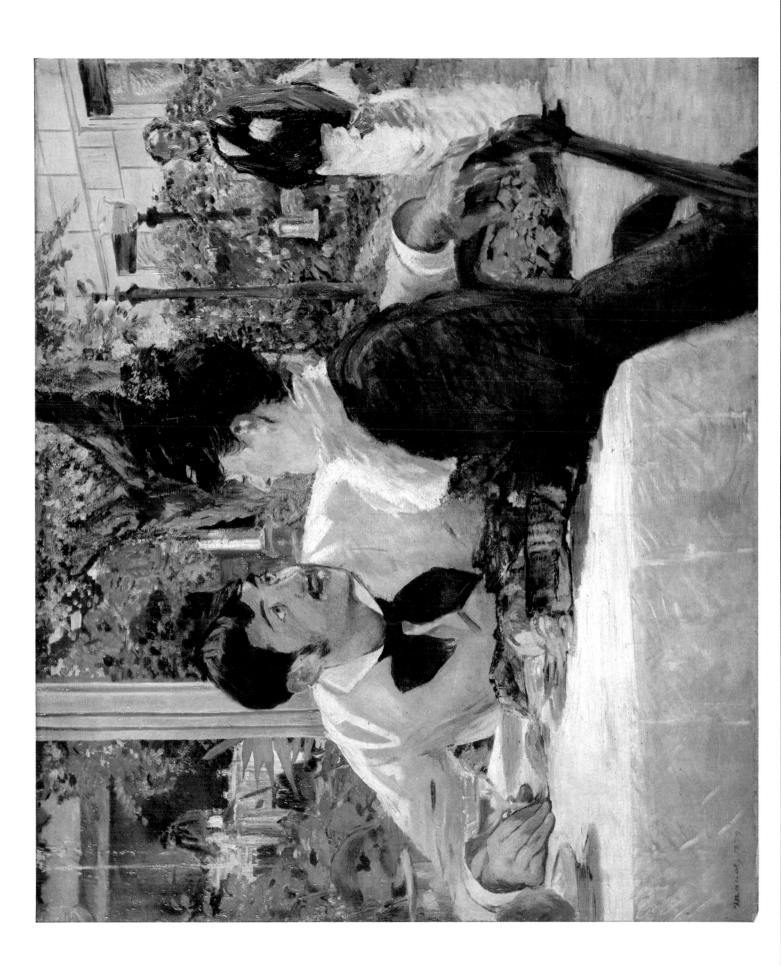

Painted 1879
Pastel on canvas, 21 3/4 x 18 7/8 in.
Courtesy of The Metropolitan Museum of Art, New York
(Bequest of Mrs. H. O. Havemeyer, 1929, The H. O. Havemeyer Collection)

Portrait of George Moore

Among the portraits Manet has left us of his male friends, I would rank none higher than this pastel of George Moore. It is one of his rare life-size heads. Moore, or *l'Anglais de Montmartre* as they called him, was a refined dilettante: a painter, poet, dramatist, and art critic who rose at last to prominence among the English writers of his day. He appealed to Manet, according to Moreau-Nélaton, "on account of his exotic and bohemian way of life, his pale, languid face, and his red hair." Manet has given him the reddish hair that betrays his Irish birth. George Moore was a poet of great subtlety, with a delicate humor that did not kill his sensitive charm. He originally came to Paris to paint and was friendly with Villiers de l'Isle Adam, Rimbaud, Verlaine, Duranty, Zola, and Mallarmé. His first writings ("*On Manet*," *Confessions of a Young Man*, *Modern Painting*) appeared in *La Revue Indépendante*. This periodical had been founded by Edouard Dujardin, the originator of the *monologue intérieur*. However, after the study by Margaretta Salinger, there is no need for me to dwell on Manet's friendship with Moore.

Manet did several portraits of Moore: one, full-length, in oils, was never completed; another is simply a sketch. This one is done with big strokes of pastel that repeat the bold and brilliant manner of his brushwork. So lifelike are the pose, the coloring, and the expression in the eyes that one feels one can almost hear the English voice of this man, who was so much in sympathy with Parisian life and art.

In *Confessions of a Young Man*, George Moore wrote a most evocative description of Manet, picturing him as he walked into the Nouvelle-Athènes: "At that moment the glass door of the café grated upon the sanded floor, and Manet entered. Although by birth and art essentially a Parisian, there was something in his appearance and manner of speaking that suggested an Englishman. Perhaps it was his dress—his clean-cut clothes and figure. That figure! those square shoulders that swaggered as he went across a room, and the thin waist; and that face, the beard and the nose, satyr-like shall I say? No, for I would evoke an idea of beauty of line united to that of intellectual expression...."

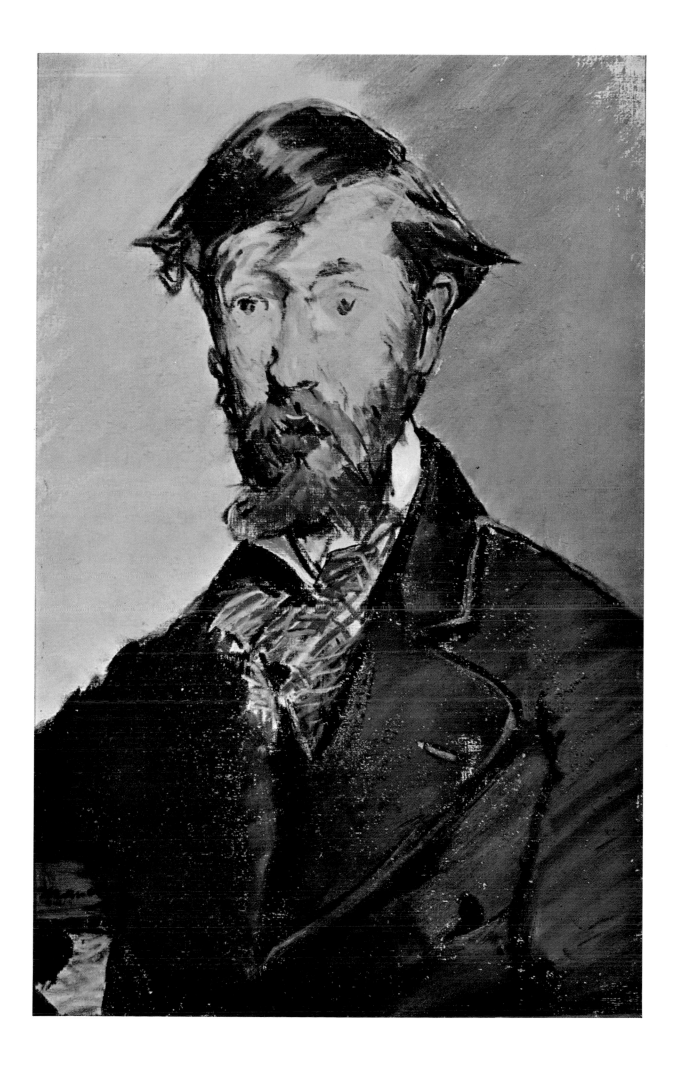

Painted 1879–80
37 x 29 1/8 in.
Museum of Impressionism, The Louvre, Paris

Portrait of Clemenceau

In its emphasis on linearity, this portrait is exceptional. Rather than work with outlines, Manet usually conceived his figures and objects in painterly terms of mass and light. He was unequaled in the art of putting the accent in just the right place with a stroke of his brush. Yet even then, he was accused of smudging his colors. Despite this criticism, Georges Clemenceau (as in Manet's other portrait of him, where he is shown in the Chamber of Deputies; figure 47) appears before us—resolute, self-willed, dictatorial, ready to face anything, to attack, to retort—exactly as he was in 1880, when he was a deputy for Montmartre. Clemenceau was thirty-nine when this portrait was painted. He was born on September 28, 1841; at Mouilleron-en-Pareds (Vendée). After studying medicine, he traveled in the United States and then returned to Paris in 1869. Establishing himself in the eighteenth arrondissement, he was appointed mayor of Montmartre on September 4, 1870. After various vicissitudes, he ceded his place to the members of the Paris Commune and handed in his resignation to President Grévy. He reappeared on the political scene in July 1871 with his election to the Clignancourt Municipal Council.

The Clemenceau portraits (the artist did one of Mme Clemenceau at the same time) gave Manet considerable trouble because of the difficulty of persuading Clemenceau to sit. The artist admitted to Antonin Proust that above all he wanted regular sittings. "When I have started on something, I am terrified that the model will not come back as often as I would like. People come and sit for me and then off they go, thinking that I can finish it just as well by myself. But that is just what I can't do."

Clemenceau posed for this picture in the studio in the rue d'Amsterdam.

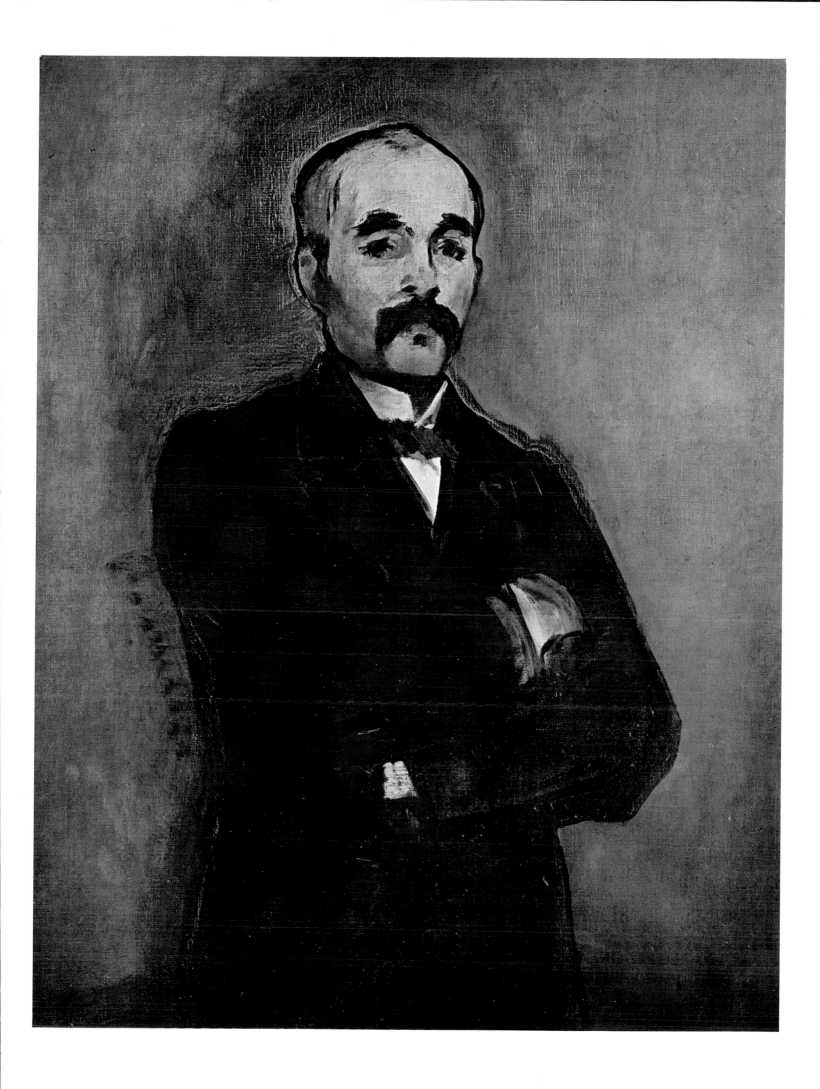

Painted 1880
51 1/2 x 38 1/2 in.
The Toledo Museum of Art, Toledo, Ohio
(Gift of Edward Drummond Libbey, 1925)

Portrait of Antonin Proust

This symphony in dark blue against a brown background is a portrait of a man who had been a friend of Manet since childhood and later wrote an account of the artist as he knew him. We see him here, his hand on his hip, poised with admirable elegance and aplomb. Manet had painted him before, in 1856 and again in 1877; this portrait was the last of the series. (There is a preliminary study for this picture, also painted in the studio in the rue d'Amsterdam, that was given to Proust in 1884.) The rendering of the clothing is especially successful. Recalling what Diderot said about "modern" dress—that if it was unworthy, one should not be bothered with it—Manet remarked to Proust, "What a foolish idea; an artist must live with his times and paint what he sees."

Who was Antonin Proust: Born at Niort on March 15, 1832, he was the son of a liberal deputy for the Deux-Sèvres, had traveled widely and had been a journalist. In 1870 he was a correspondent for *Le Temps* and became Gambetta's secretary on September 4, at the fall of the Second Empire. During the siege of Paris he acted as Minister of the Interior. Losing office in the elections of 1871, he contributed to *La République Française* and turned to teaching. Later, as a member of the Budget Committee, he wrote the report on Fine Arts and assisted in founding the Museum of Decorative Arts. Reelected in 1881, he became Minister of Fine Arts in Gambetta's short-lived government and arranged for Manet to be made a chevalier of the Legion of Honor.

This portrait was exhibited in the 1880 Salon, but as Manet wrote to Proust, it was badly hung, "at an angle near a door, and the criticism of it was even worse. But it is my lot to be reviled, and I take it philosophically.... Your portrait is above all sincere. I remember as though it were yesterday how I dashed off the glove you were holding. And when you said to me at that instant, 'Please, not another stroke,' I felt so close to you that I could not resist the impulse to embrace you. I only hope that no one ever has the idea of hanging that painting in a public gallery."

For a moment, as I read those words, I fancy that the Toledo Museum is not a public gallery but a place of meditation, where this portrait can take on all its pictorial significance.

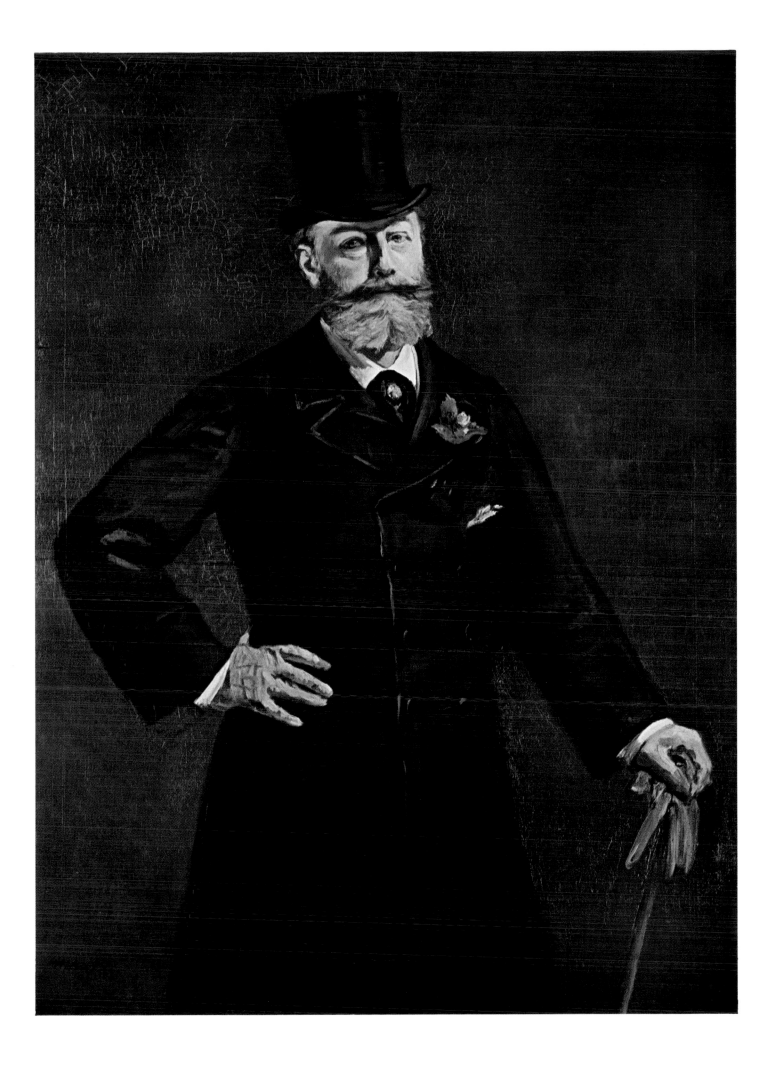

Painted 1880
6 1/2 x 8 1/2 in.
Museum of Impressionism, The Louvre, Paris

Asparagus

This picture, donated to the Louvre in 1959 by Sam Salz, is a masterpiece of spontaneous, direct painting. The asparagus is there before our eyes, as succulent in the picture as in real life. The few brush strokes against the gray background display a sureness of touch that is almost, but not quite, virtuosity. The painting is a miracle of color, touch, and feeling. Although Manet had no great gift for drawing, his brushwork was of the highest order. The cold tones of the background contrast with the warm ones of the asparagus and with the greens and blues of the tip. The colors seem to herald the colored drawings used for different kinds of expression by Van Gogh and Dufy.

It would be interesting to reproduce a Dutch still life by Pieter Claesz side by side with this marvel of brushwork. The solid forms of the old school of painting are in the process here of dissolving into the atmosphere. In the seventeenth century, on the other hand, each object is considered a separate entity.

This work is in fact one of those which best illustrate Manet's contribution to painting. Small as it is, it may be regarded as a test of his genius. Bypassing Monet and Sisley, Manet here brings us right up to Seurat in his extraordinary feeling for color and light, and in the way he has painted this small shoot to make it the living embodiment of all creation.

Painted 1882
37 1/2 x 51 in.
Courtauld Institute of Art, London

A Bar at the Folies-Bergère

Looking at this scene of night life, where under the artificial light, people, flowers, fruit, and bottles are grouped against a background of their own reflections, one is indeed tempted to consider the favorite question of the "picture-dissectors," namely, "Where is the mirror?"

Certainly anyone who set out to determine the exact position of the mirror in this picture would have great difficulty, just as they would in establishing the position of the bearded man whom we see only in reflection. This is one of those distortions which delight us by their daring (there is a similar one in **Le Bain Turc** by Ingres). The still life in the foreground has been much admired; the champagne bottles are magnificent. In the dish of fruit, Manet for once has abandoned the lemon in favor of the orange. On the marble-topped counter two roses stand in a cordial glass. But the finest feature of the picture is without doubt the girl, with her blonde hair and rosy complexion. Manet has painted her wearing his favorite black velvet ribbon around her neck. This beauty, tired yet still attentive to the customers, was a model called Suzon, introduced to Manet by Henry Dupray, the painter of military subjects. He can be glimpsed with Latouche in the stagebox at the extreme left.

Jeanniot, who watched Manet working at this picture, published his recollections of it in *La Grande Revue*, on April 10, 1907:

I sat on a chair behind him and watched him at work. Although he painted from life, Manet did not by any means copy it; I realized his great gift for simplification. He began to build up the woman's head, but not by the means that nature offered him. Everything was concentrated: the tones were lighter, the colors brighter, the values more homogeneous. The whole formed a light and tender harmony. We spoke of Chaplin. "He is very talented, you know," said Manet, while painting in with small strokes the gold paper around the neck of a champagne bottle.

Other people joined us, and Manet stopped painting to go and sit on the divan against the wall on the right. It was then that I saw how his illness had undermined him. He walked with a stick and appeared to tremble.

Exhibited in the 1882 Salon, this picture, Manet's last important work, won him the praise of the perceptive critic, Ernest Chesneau. "Manet," he wrote in *L'Annuaire illustré des beaux-arts*, "does not immobilize his forms; he surprises them in their affective movement. His formula of art is very new, very personal, very piquant; it marks the artist's conquest of the world of external phenomena, and it will not be lost on future generations."

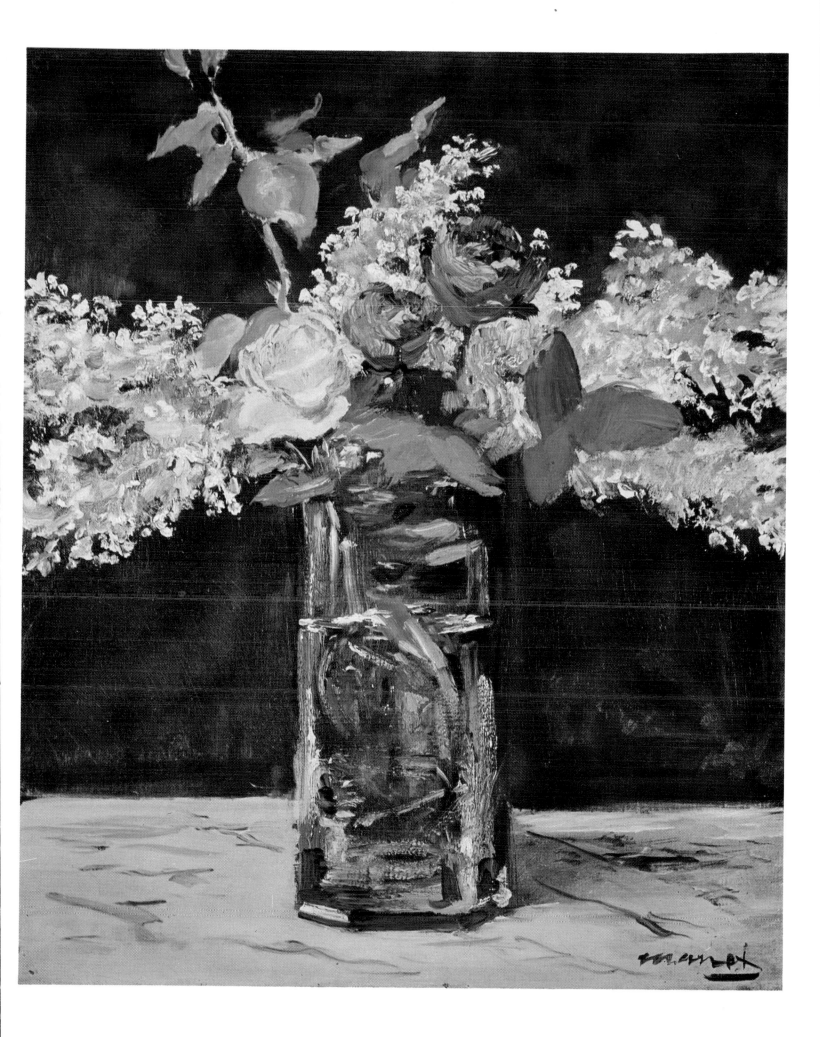

Acknowledgments

74 **Hackney Cab from the Rear**
Wash, 4 3/4 x 3 5/8 in.
Bibliothèque Nationale, Paris

My first thanks must go to Mme Jacqueline Bouchot-Saupique, Curator of Drawings at the Louvre, and to M. Edmond Pognon, Curator of the Print Department at the Bibliothèque Nationale, who facilitated my task by giving me access to the reserves of their collections. I would also like to thank Mlle Damiron, Director of the Bibliothèque d'Art et d'Archéologie, who permitted me to examine records containing miscellaneous items pertaining to Manet.

Above all I must acknowledge how valuable to my research I have found the catalogue by Paul Jamot and Georges Wildenstein and the admirable work by Adolphe Tabarant, who knew by heart the history of every painting by Manet.

Finally I should like to thank all the collectors and curators of museums who have aided me in making this choice of paintings, which we hope will be worthy of Manet.

Project Manager: Samantha Topol
Editor: Jon Cipriaso
Designer: Martin Perrin
Production Manager: Justine Keefe

Library of Congress Cataloging-in-Publication Data

Courthion, Pierre.
Edouard Manet / Pierre Courthion.
 p. cm. — (Masters of art)
Includes bibliographical references and index.
ISBN 0-8109-9145-4
1. Manet, Edouard, 1832–1883—Criticism and interpretation. I. Manet, Edouard, 1832–1883. II. Title. III. Series: Masters of art (Harry N. Abrams, Inc.)

ND553.M3C68 2004
759.4—dc22

 2003022521

This is a concise, paperback edition of Pierre Courthion, *Manet,* originally published in 1959.

Printed and bound in Japan
10 9 8 7 6 5 4 3 2

Harry N. Abrams, Inc.
100 Fifth Avenue
New York, N.Y. 10011
www.abramsbooks.com

Abrams is a subsidiary of

LA MARTINIÈRE